LEGENDARY

— OF —

OXNARD

CALIFORNIA

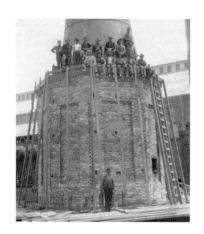

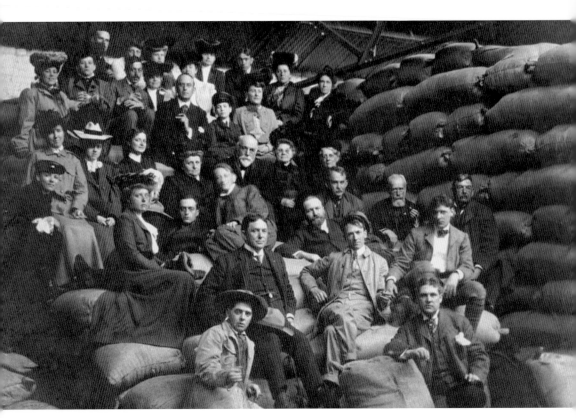

Oxnard Sugar Factory Employees
Sugar factory employees and their wives gather for a group photograph, lounging on bags of sugar. (Author's collection.)

Page 1: Smokestack at the Pacific Sugar Factory
The workers of the Oxnard Construction Company are pictured at the base of the 150 smokestack, around 1898. (Courtesy Bob Delp.)

LEGENDARY LOCALS

OF

OXNARD

CALIFORNIA

JEFFREY WAYNE MAULHARDT

LEGENDARY
LOCALS

Legendary Locals is an imprint of Arcadia Publishing
Charleston, South Carolina

Printed in the United States of America

Library of Congress Control Number: 2012948459

For all general information, please contact Arcadia Publishing:
Telephone 843-853-2070
Fax 843-853-0044
E-mail sales@arcadiapublishing.com
For customer service and orders:
Toll-Free 1-888-313-2665

Visit us on the Internet at www.arcadiapublishing.com

Dedication
This book is dedicated to my mom, Jean Marie (Wilson) Maulhardt. Putting together this book took a lot of time and sacrifice, things my mom taught me in my life.

On the Cover: From left to right:
(TOP ROW) Albert F. Maulhardt, Bedford Pinkard, James A. Driffill (courtesy Pomona Public Library), Estelle Cooper (courtesy Kerri Pell Dominguez), Charles Donlon.
(MIDDLE ROW) Bill Soo Hoo, Martin V. and Martha Smith (courtesy Stacy Cannon and Vickie Pozi), Christian Borchard, Dr. Manuel Lopez, Cesar Chavez (New York World-Telegram & Sun Collection, Prints and Photographs Division, Library of Congress).
(BOTTOM ROW) Simon Cohn, Michelle Serros (courtesy Marie Gregorio-Oviedo), Rev. John S. Laubacher, Neo Tagasuki, Henry T. Oxnard. All photographs are from the author's collection, except where otherwise noted.

CONTENTS

Acknowledgments 6

Introduction 7

CHAPTER ONE Pioneers 9

CHAPTER TWO Groundbreakers 43

CHAPTER THREE Civic Leaders and Public Servants 63

CHAPTER FOUR Interesting Characters 81

CHAPTER FIVE Sports 97

CHAPTER SIX Entertainment: Music, Actors, and Writers 109

About the Foundation 126

Index 127

ACKNOWLEDGMENTS

I would like to thank the following individuals: Alan Maulhardt, Armando Lopez, Bert Donlon, Bill Parry, Brian Benchwick, Charles Johnson, Chuck Covarrubias, Connie Korenstein, Dr. Frank Barajas, Ed Stile, Erica Gonzalez, Frank R. Naumann, Gary Blum, Jeff Hershey, Jullianne De La Cruz, John and Linda Dullam, Lisa Pavin, Lucia Flores, Lou and Martha Cvijanovich, Loretta Frank, Manny Lopez, Mike Maulhardt from Davis, Mikey and Fatima Garcia, Morey Navarro, Pat Frank, Sal Banuelos, Sylvia Munoz Schnopp, Tiffany Frary, and Tiffany Israel.

All photographs are from the author's collection, except where otherwise noted.

INTRODUCTION

It all started with the sugar factory in 1898. Without the sugar factory, farmers would have continued to migrate to the wharf town of Hueneme, which would have grown to include the farming areas that now make up Oxnard. Instead of the Hill Ranch as the epicenter, it could have been the Bard property or the Donlon ranch. Or, New Jerusalem (the town that became El Rio) could have expanded to encompass the current area of north Oxnard and El Rio. Or, maybe the abandoned town of Springville, the community between Camarillo and El Rio/Oxnard, could have survived the coming of the rail line in 1900 that killed it while establishing the town of Camarillo. In any case, once the Oxnard brothers and their investors committed to build a $2-million factory that could provide enough work for a small army, the future was set. A new town was on the way, and an influx of people, buildings, and activity was right around the corner.

Up to this time, the majority of the farmers grew dry crops that needed little or no water beyond the winter or spring rain. Crops like barley and corn were most popular. Lima beans came along, and, suddenly, the farmers made a little money. Demand lessened with the increase of production, however, and a cash crop was needed to boost up the profits. Land prices were still low, averaging $10 an acre in 1872 and rising about two percent per year until 1900. If the farmers could find a crop that was in high demand, they could demand a higher price for their land. In the early 1890s, many farmers tried growing potatoes. They even put their money together to build a starch factory in Hueneme, but it was to no avail.

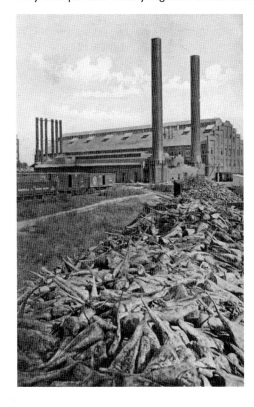

Sugar Factory Delivery
Pictured is a load of sugar beets being delivered to the Oxnard sugar factory. (Author's collection.)

Everything changed with the introduction of sugar beets, which became the cash crop everyone was seeking. Profits per acre soared, but there was a price to pay; the farmer's investment was a larger financial risk. No longer did he have to borrow the seed from Achille Levy or Simon Cohn; there was a commitment to the sugar factory for seed and labor. A good year could bring about great returns, but a year of bad weather or bad luck could mean putting the farm up for sale.

With the factory came the town, and with the town came the businesses and people. Most of the businesses (and some of the buildings) from Hueneme came over. Barns were moved and converted into hotels. A whole new labor force was required for planting, thinning, harvesting, and production. No longer could a farmer rely on his family and neighbors for help with the harvest.

The early years of Oxnard were full of hope, expectations, some trials, and many errors. While several churches of all denominations were established in the area, so were the saloons. By 1908, a decade after the townsite was laid out, the Ventura County directory listed seven churches, 13 saloons, and 11 billiard halls. It would take a few years and a lot of hard work to try to balance the scales of justice.

Over the years, many people have contributed to the growth and success of Oxnard in a legendary way, and their stories are worth noting. Of course, no list is complete, and the goal of this writing is encourage people to bring forth their images and stories so we can write the next volume.

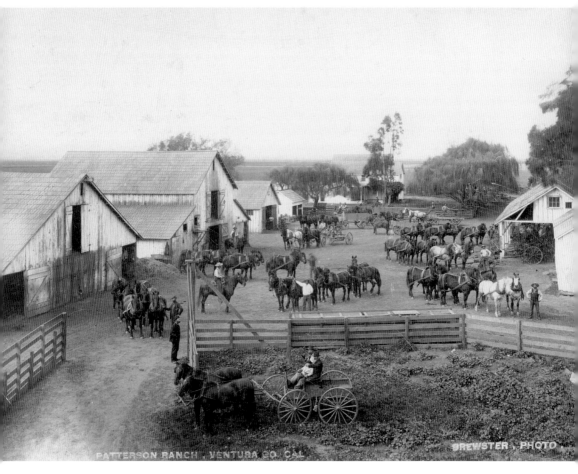

Patterson Ranch
Pictured is the Patterson ranch that was run by Charles J. Daily (visible wearing the white coat and sitting on the carriage in the foreground). (Courtesy Eric Daily.)

CHAPTER ONE

Pioneers

The word *pioneer* has several definitions, but the one that seems to best fit the pioneers of Oxnard is "to begin to take part in the development of something new." Indeed, both agriculture and settlement were new to the area that became Oxnard. While there was much migration among the native Chumash populations, the plain itself was essentially left undisturbed and uninhabited on a permanent basis. By the time the first pioneers (the Gonzalezes, Borchards, Donlons, McGraths, and others) arrived in the 1860s and 1870s, the virgin soil, rich in alluvial deposits, was the agricultural equivalent of the gold sought by the forty-niners in the northern part of the state. Settlers flocked to the area, bringing their sheep for river-bottom grazing, plows to break up the mustard plant–covered earth, and the determination to take advantage of this golden opportunity.

Oxnard was also the birthplace of many innovative ideas, including the pioneer efforts of Dr. William Livingston and the introduction of the birthing method known as "twilight sleep" that brought strangers from all over the world to Oxnard to have their babies. Then there are the descendants of pioneers—Chuck Covarrubias, Gary Blum and Frank Naumann—all working to preserve the legacy left by their ancestors.

Original Grantees

Of the eight grantees of Rancho El Rio de Santa Clara o la Colonia, brothers Leandro and Rafael Gonzalez had the greatest impact. The grant request came in 1837, but went through several challenges before it was confirmed. Leandro Gonzalez, born in Santa Barbara in 1792, was the elder of the two Gonzalez brothers. He was only four years old when his father, Rafael Gerardo Gonzalez, died from being served poisoned fish by a group of Indians in retaliation for a flogging he had given for allowing the crows to eat his corn. Leandro was the administrator and majordomo of Mission Santa Barbara from 1840 to 1843. He lived the majority of his life there and was still in Santa Barbara in 1850. He hired Bruno Orella to work on the Colonia property, where the Gonzalez brothers built a series of adobes to help them tend to their cattle. In 1858, Orella married Leandro's daughter Mercedes, and but three months later, Leandro died. His widow, Josefa Guevera Gonzalez, inherited half of Leandro's property, and the remaining half was divided equally into sixths among Mercedes and her siblings. Mercedes sold her portion to Dwight Hollister in 1867, and Hollister, who lived in Sacramento, rented the 633 acres out. It was soon rented to Peter Donlon. The next year, Leandro's son Ramon sold the remaining portion of his family's rancho to William Rice from Contra Costa County for $20,000, or $4 an acre. By 1870, Ramon was listed as a cattle trader, and his estate was worth $4,000. By 1880, he was listed as a proprietor. (Courtesy Bancroft Library, University of California, Berkeley.)

Rafael Gonzalez

The grantee whose family has had the greatest legacy on the Colonia Rancho was Rafael Gonzalez. Rafael, who was born shortly after his father was poisoned, enlisted as a soldier in 1916 and spent his early service years as a guard at the Santa Inez Mission. He was also on guard in Santa Barbara in 1818 when word came that the pirate Hippolyte de Bouchard and his crew had sacked and burned the settlement in Monterrey and that they were soon to sail to the southern coast. In 1925, Rafael married Antonia Gueverra, the sister of his brother's wife. He served 10 years as a soldier and reached the rank of corporal. By 1929, he became the alcalde mayor of Santa Barbara. In 1838, Rafael was appointed administrator for Mission San Buenaventura by Governor Alvarado. As administrator, he had to account for every asset, credit, and debit. In July, the mission reported 2,200 head of cattle, 1,670 sheep, 799 horses, 35 mules, 65 goats, 13 barrels of wine, 5 barrels of brandy, and various quantities of wheat, corn, peas, hides, tallow lard iron, and soap.

Rafael, who has gone down in history as one of the better administrators of the California missions, resigned in February 1942. According to the 1850 Santa Barbara census, at ages 54 and 52, respectively, Rafael and Antonia had 10 children between the ages of 10 and 24, including one adopted child, and Rafael owned $5,000 of property. His was one of 27 households—out of a total 170 in the entire (present-day Ventura) county—to own at least this amount. According to the 1860 census, his occupation was stock raiser, his real estate was valued at $4,500, and his estate was worth $30,000. However, another series of droughts (1857–1858 and 1863–1864) cost him much of his cattle. Rafael sold a portion of his land to Jose Lobero in 1864 and sold another portion to Juan Camarillo in 1865. His son Juan Gonzalez retained 50 acres of the rancho in 1867 near the corner of present-day Gonzales Road and Oxnard Boulevard, where he raised horses and grew lima beans. Gonzalez's daughter Maria also received 50 acres. By 1870, Rafael's real estate was valued at $2,000, and his estate at $600. In 1880, he was living on Garden Street with his daughter. The Gonzales ranch is pictured here around 1910. (Courtesy Chuck Covarrubias.)

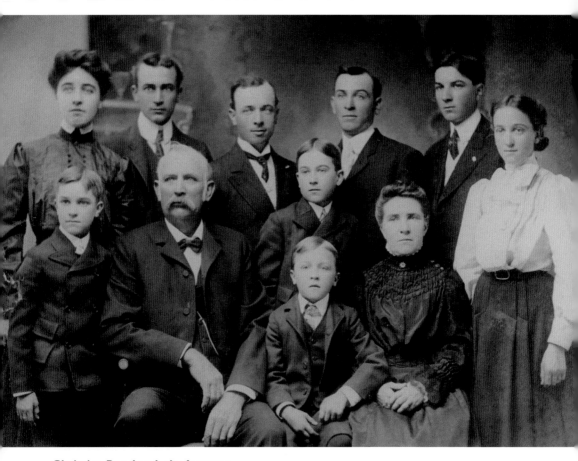

Christian Borchard, the Journey

While many of the stories about Johannes "Christian" Borchard are of a mythical nature, his accomplishments are legendary. Borchard, along with his son John Edward Borchard, is credited with planting the first commercial crop on the present-day Oxnard Plain in 1867. Christian was born in 1816 in Nesslerode, Germany, a small village near the medieval town of Duderstadt. His adventurous spirit took him to Ohio in 1843, and around the time of the California Gold Rush, he hitched his American oxen behind a wagon and traveled west with his wife, Elizabeth, and son.

The trip across the Plains proved treacherous; the family witnessed a massacre by natives and suffered the loss of their stock. They arrived in Grass Valley before moving on the French Camp at Red Bluff. After two years in the mines, Christian used his earnings to open a hotel in Colusa. He next moved near the Feather River, then Marysville, and then Antioch, where he raised cattle and crops. However, a flood in 1866 wiped out most of his ranch, forcing Christian to seek a new home once again. He packed up his family and headed south toward Anaheim, where a large German population had gathered to form a community. On the way, an accident occurred that left the family temporarily stranded at the Santa Clara River crossing. Noticing the wild mustard plant on the nearly empty plain, Christian realized he did not need to search any further. He inquired about the land and found out that much of it belonged to the Gonzalez family. The land was undivided, so Borchard offered to buy 1,000 acres, choosing a portion along the river that included an adobe home once occupied by the Gonzalez family. In October 1867, Christian paid Jose Lobero, who had purchased the land from Gonzalez, $3,200 (or $3.20 an acre). This was the first parcel of land from the Rancho el Rio de Santa Clara o la Colonia to be sold outside the original eight grantees' families. Pictured here is the family of John Edward Borchard, son of Christian. (Author's collection.)

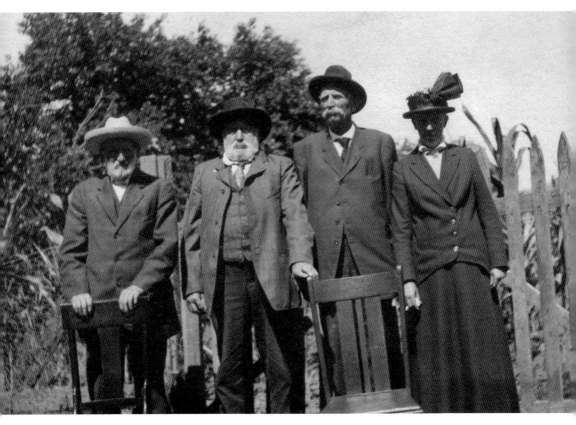

The First Crop

The Borchard family took up residence in the Gonzalez adobe. Christian and son Ed reaped 25 tons of wild mustard, which they sold for 2¢ a pound. They next set out to plant 30 acres each of wheat and barley. While the wheat failed because of the excessive moisture in the air, the barley thrived, becoming the area's first commercial crop and helping to set the scene for the region's agricultural future. Christian continued harvesting the mustard plant and raised 1,500 head of sheep. In 1870, he bagged 5,710 sacks of mustard seed and produced 1,200 bushels of barley and 20 tons of hay.

Christian was also instrumental in establishing the original Santa Clara Church. In 1876, he donated the land and was part of the building committee that also included Dominick McGrath; Thomas Cloyne; and brothers Gottfried, Jacob, and Anton Maulhardt.

Christian also hosted the first-annual German Society gathering at his ranch in 1878. A parade of wagons decorated with German and American flags started in Ventura at 9:00 a.m. and proceeded to the grounds of the Borchard farm, where a stage was erected with tables and chairs and swings for the children while everyone was treated to a lunch. The Ventura Brass Band provided the music. Games included sack races and a grab for 10¢ pieces in a sack of flour. The local paper reported that there was an abundance of beer and native wine on the grounds, but there was "very little drunkenness." Over 600 people attended, close to half the population of the area.

Finally, Christian's passion for life is what allowed him to accomplish so much, myth or near myth. After his wife, Elizabeth, passed away in 1887, Christian, age 71, returned to Germany to take another bride. He brought back a 20-year-old wife, Anna Weinrich, and they produced five children: Frank, Freda, Matilda, Louis, and Teresa (who was born not long after Christian's 82nd birthday in 1898). Three decades after Christian harvested the wild mustard and planted the first commercial crop of barley, the Oxnard Plain had been converted to a sugar city that was a supported by a $2-million factory. Pictured from left to right are Borchard cousins Caspar, Johannes, Ed, and Mary. (Author's collection.)

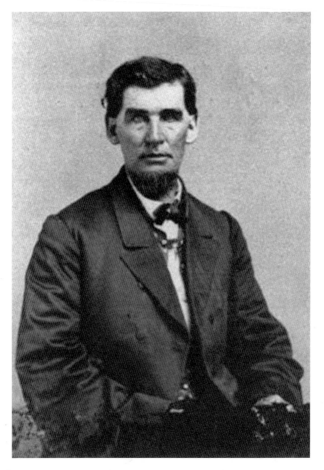

James Young Saviers

James Saviers was born in Richland County, Ohio, where he was trained to be a wagon maker. He first came to California with John C. Fremont in 1845 and traveled to Southern California with the troops in 1847. In 1850, Saviers crossed the plains again and ended up in Hangtown, California, where he spent a year mining and picking up stakes before relocating to Shingle Springs, Amador County. There, he opened up a shop to service the influx of gold-seekers. One day, while hunting for game, he was attacked by Indians and took five arrows and two gunshots to the body. In his recounting of the tale published in the *Hueneme Herald* on June 2, 1896, he said, "When I left the Indians there were four arrows sticking out of my body." After recovering, Saviers returned to Ohio and married Elisabeth Jones in 1855. By 1860, he led a wagon train of 60, which included his brother John Young Saviers, back to California, where he settled in Yuba County for the next three years. He next settled in Contra Costa County and, in 1869, he and partner Jacob Gries purchased 682 acres at $15 an acre. Elisabeth passed away. Soon after, Saviers remarried, this time to Martha "Mattie" Polley. Mattie, who was active in helping James make their place a model ranch, assisted in the establishment of a nursery on the property and began importing red and blue gum trees that served as the first set of windbreaks in the county. Saviers also built a massive barn (48 feet by 70 feet), big enough to store 90 tons of hay and stable 38 horses. Saviers took on the duties of justice of the peace for the Hueneme Township, which included the present-day area of Oxnard. His brother John Young Saviers was also a justice of the peace, serving the Pleasant Valley Precinct (present-day Camarillo) as early as 1873. A portion of the Saviers ranch was sold to a contingency of farmers who offered the land to the Oxnards as an enticement to build the $2-million sugar factory between 1897 and 1898. (Author's collection.)

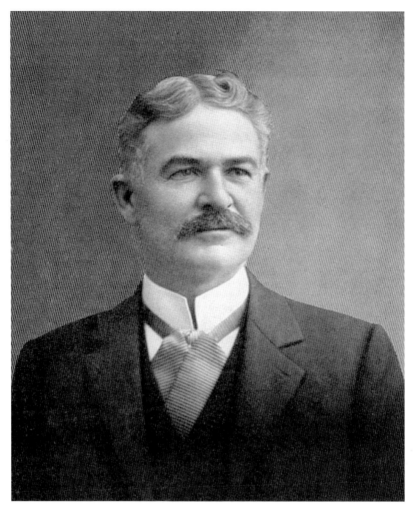

Thomas A. Rice

Thomas Rice was born in Jackson County, Missouri, in 1849. His parents, William and Louise Rice, came west in 1859, driving 1,000 head of cattle along the way, and settled in Contra Costa County, where William and Louise remained. William, however, purchased several thousands of acres from the Gonzalez family in the late 1860s, and by 1870 sons William Ish Rice and Archibald Rice were farming near the river bottom. Thomas Rice relocated to the area in 1883 and was given 338 acres that his father had purchased from James Saviers. This property would later become the grounds for the Oxnard sugar factory. Thomas also owned an additional 900 acres off of present-day Rice Avenue and had a fishpond that was sometimes used by the Pleasant Valley Baptist Church for their baptism ceremonies. Thomas was active in civic affairs, serving a three-year term as county supervisor as early as 1885. He was instrumental in establishing the First National Bank (originally called the Bank of Oxnard) and also served many years he served as a district school trustee. He was also known for his generosity of spirit. He bought an old church building and gave it to the First Church of Christ, Scientist, and he was a booster who helped organize the baseball game in Oxnard when the New York Giants played the Chicago White Sox in 1913. He was also a prominent Mason of both the York and Scottish Rites, as well as a Shriner. When he passed away in 1917 at the age of 68, the *Oxford Courier* described him as being "endowed with a kindly spirit and a disposition to please and harmonize." In a final tribute, flags throughout the city flew at half-mast. (Author's collection.)

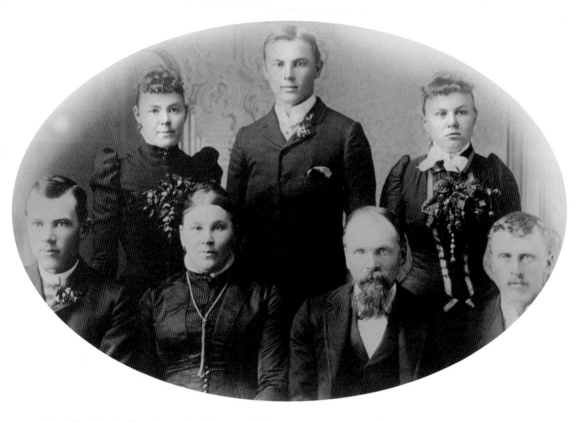

The Maulhardt Brothers, the Journey West

The Maulhardt family has been associated with several significant developments in the area, from harvesting the first crop to introducing the sugar beets that enticed the Oxnards to build the sugar factory. Along the way, the family has sprouted farmers, doctors, a mayor, businesspeople, writers, pilots, athletes and educators, and its branches now extend into a number of influential area families, including the Borchards, Buells, Cartys, Engstrums, Kohlers, Liedels, and more. The first Maulhardt to venture from Germany to the new world was Anton Maulhardt, the youngest of the three brothers who made Ventura County their new home. The Maulhardts were from Mingerode, Germany, near Duderstadt. After losing to the Prussians in a three-day battle in August 1866, Anton was sent to check on the opportunities in California, where fellow countryman Christian Borchard was already staking a claim. By March 1867, Christian Borchard was in Ventura County and the brothers followed. Traveling on the same boat from the port of Bremen were Gottfried and his wife, Sophie; Jacob and his wife, Doretta, and one-year-old son Henry; and the nephew of Christian Borchard, Caspar Borchard. Each brother traveled down the coast at a different pace. They all spent some time in Contra Costa County before traveling south. Anton stopped off at Tulare County. Jacob, who worked as a butcher on the ship over, welcomed the birth of daughter Emma, in Contra Costa County in 1868. He took his family south to Tulare to find work with sheep, and a third child, Louis, was born in 1869. Soon after his birth, the family was able to join Gottfried and Sophie, who were already in Ventura County. Gottfried and Caspar Borchard were renting land from Juan Camarillo on the Colonia Rancho that they would eventually buy. While Caspar returned to Germany for a short period, his brother Johannes arrived in 1871. By December 1872, Jacob and Gottfried Maulhardt, along with Johannes Borchard, purchased 1,243 acres from Juan Camarillo for $12,430, or $10 an acre. The land stretched from Rice Avenue to Juanita Avenue and from Camino Del Sol to the 101 Freeway. Pictured from left to right are (first row) Louis G. Maulhardt, Doretta Maulhardt, Jacob Maulhardt, and Henry W. Maulhardt; (second row) Emma Maulhardt Carty, Adolf Anton, and Mary Maulhardt Hartman. (Author's collection.)

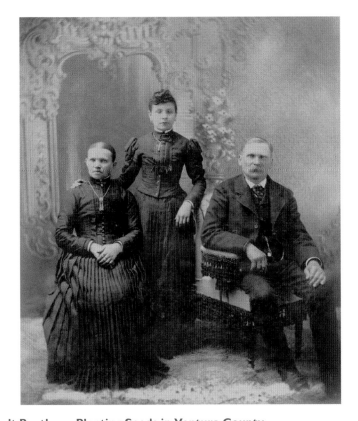

The Maulhardt Brothers, Planting Seeds in Ventura County

Gottfried and Sophie built the first residence on the property, a "neat little cottage house hid away among acacias and other ornamental trees and flowers." He devoted the majority of his land to barley, with a small portion for corn production. He also grew a vineyard of 250 grapevines for the "choicest wines," which he stored in his brick winery and delivered to the Santa Clara Church in New Jerusalem. The cottage house and winery still stand 140 years later and are the cornerstone buildings for the Oxnard Historic Farm Park Museum. Sadly, the children of Gottfried and Sophie did not survive the harsh reality of pioneer life. The couple adopted a young Latina girl, Anna, from an orphanage in Santa Barbara. She stands between them in this c. 1893 photograph.

Jacob and his wife, Doretta (Kohler), raised five children to adulthood. They arrived in California in 1867, carrying their infant son Henry with them as they walked across the Isthmus of Panama before tracking down a boat to take them to San Francisco. Jacob served as the butcher on the ship to help cover the cost of the passage. He used this skill to work his way down the California coast until the family settled for good after the birth of their third child, Louis, in 1870. As the *Ventura Signal* put it in 1878, "Mr. Maulhardt came here with a wife and three children and not a cent in his pocket; rented land the first year at fifty cents per acre and went to work. Next, he bought 400 acres paying $10 an acre." Jacob and his brothers served on the building committee to establish the Santa Clara Church in 1877. He also served with Henry Oxnard and James A. Driffill on the original board for the Bank of Oxnard. With his nephew Albert Maulhardt (son of Anton, pictured below), he was active on the committee that helped establish the sugar industry. Anton had relocated to Ventura County in 1875, purchasing 411 acres from James Stevenson. In 1889, Anton moved to Los Angeles while Albert was attending St. Vincent's College (now Loyola). Anton died in 1891, and Albert returned to the ranch, taking over the operations and eventually beginning his experiment with sugar beets. His sister Emma married Fred Engstrum Jr., son of the prominent Los Angeles–area contractor Fred Engstrum, whose crew built the Oxnard Hotel, the Masonic Lodge, and the first Oxnard High School. (Author's collection.)

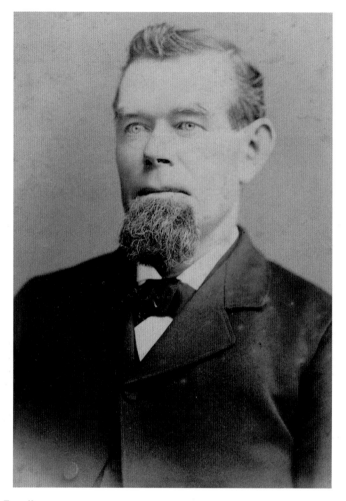

Peter Donlon Family

Few people were as powerful and influential as Charles Donlon during the early years of Oxnard. Charles was the son of Peter Donlon (pictured), who married Catherine "Kate" Cloyne (both were from Derry Shanogue, County Longford, Ireland). They traveled to the United States during the Irish Potato Famine of the 1840s and landed in New York. They settled in Dublin, California, in Alameda County, where Peter ran a hotel. In 1870, Peter sold his holdings and bought 533 acres from Thomas Bard far $13.25, near the town of Wynema (Hueneme). Within 10 years, Peter Donlon was cultivating 300 acres of barley, 15 acres of corn, 20 acres of alfalfa; he also had 300 hogs and plenty of horses and cows. Peter and Kate Donlon raised three boys and two girls: James, Charles, Joseph, Mary, and Ida. All were productive in their own right, but none more so than Charles. After their mother died in 1885, the two young girls, ages 12 and 10, were sent to an orphanage in Santa Barbara for a few years. The three boys, ages 17, 16, and 14, stayed with their father. Unfortunately, a farming accident cut short Peter's life in 1888. The brothers formed Donlon Brothers and expanded their farming operations, purchasing several more ranches (including the Hollister Ranch across from Channel Island High and others near El Rio, Los Posas, Santa Barbara, and Imperial Valley). Both the El Rio and Las Posas properties were some of the first to grow lemons. To supply the necessary water for the Las Posas property, the brothers hired Hubert McCormick, who used the water-sensitive technique known as "water witching." Using a specifically chosen branch, McCormick was able to locate a site for a well on top of what is now Spanish Hills; it remains a source of water for Crestview Water Company. (Courtesy Donlon family.)

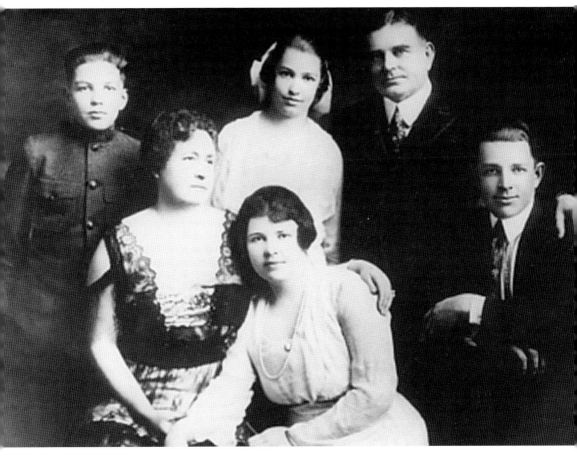

Charles Donlon
Charles married Laura Lillie in 1897, and the couple raised four children: Kathleen, Charles Bertrand, Cynthia, and Peter. The Donlon ranch employed several people, including a blacksmith; a carpenter; a Chinese cook named Gee; and another person famous for her cooking and infamous for her personal life, Lucy Hicks. Charles helped establish the Oxnard Council 750 Knight of Columbus in 1903 and was also a charter member of the Santa Barbara Lodge of Elks. He was also on the building committee for Santa Clara Church and later served on the building committee of the St. Johns Hospital. In 1912, Charles took over the presidency for the First National Bank (which later became Security First National Bank) from his cousin "Big Jim" Donlon. He served on the board of dozens of other organizations, including the Lima Bean Association, the Oxnard Citrus Association, People's Lumber, and the Hueneme Elementary School Board. It is no wonder he employed a driver, Machute "Tani" Taniguchi, to take him to his many appointments. In honor of his passing in 1932, the local businesses closed for his memorial service. (Courtesy Bert Donlon.)

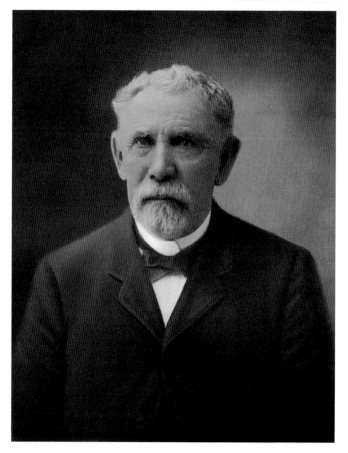

Dominick and Bridget McGrath

Farming is the legacy of the McGrath family. While certainly among the first to farm, they are also one of the last families to have maintained a tie to the land. The family's roots in Ventura County date back to the late 1860s, when Dominick McGrath (brother-in-law of Peter Donlon) traveled by horseback to Southern California in search of some bargain land. He eventually found his choice spot near the mouth of the Santa Clara River. The land was originally part land grant of El Rio de Santa Clara o la Colonia, and this portion had been passed down from original land grantee Rafael Gonzalez to his son Ramon, who sold the land to William Rice in 1868. Rice then passed the property on to his son Archibald Rice, who sold to Dominick McGrath in May 1874 for $12,000. The title to the rancho went through a series of court hearings, and by the time of the final decree on December 5, 1875, McGrath's original land total had increased from 877 acres to 1,117. Nearing his 80th birthday, Dominick McGrath set up the Dominick McGrath Estate Company in 1906. His son Joseph served as president until 1948, at which time the company was dissolved and the ranch divided. On June 11, 1848, the Rose Ranch became the grounds for the division of 10 properties that measured 5,020 acres. The properties were divided into four equal parcels according to land and production values. To determine which family gained what portion, two sealed decks of playing cards were placed on a table, one for each drawing. The first deck was to determine the order in selecting the parcels. Hugo McGrath, son of Dominick, turned the high card, followed by Robert McGrath; then Frank McGrath; and, finally, Joe McGrath. Despite the tension of splitting up the Dominick McGrath Estate and relocating several families, the family never resorted to accusations or insults. Frank McGrath's draw allotted him the Rose Ranch of 248 acres, as well as the 152-acre Graham Ranch off West Gonzalez Road and the Patterson ranch south of Fifth Street toward the shoreline. (Author's collection.)

Donating and Farming

It would be Frank and Helen McGrath's son John, along with his wife, Betty, who donated the land for the current St. John's Regional Hospital. In 1986, John and Betty McGrath were approached about the possibility of securing 48 acres of farmland located across the street from their residence. With the help of their accountant, John Hendrickson, and attorney, Laura McAvoy, the John & Betty McGrath Charitable Remainder Trust was set up for the purpose of making a portion of their ranch available for the hospital. For eight years, beginning in 1987, the trust paid the McGraths a sum of money, after which time the property was officially transferred to St. Johns Regional Medical Center. Construction on the new hospital began in 1989 and was completed in 1992 at a cost of $120 million. The family name is reflected in other parts of the city, as well. McGrath State Beach, for instance, came into existence after the family sold 295 acres to the state in the 1961. During the 1940s, the banks of the flooded low areas were reinforced with bulldozers, and a portion of the land was used for recreation and water sports. Today, the area encompasses 174 campsite and two miles of coastline. Almost 140 years since the first McGrath planted the first barley seed, the extended family has grown to over 500 descendants who carry the names Doud, Laubacher, Leonard, and more. With each generation, the number of farmers has dwindled, yet the few who have continued the family's farming legacy in Oxnard, Ventura, Camarillo, and Somis have done so with pride. Phil McGrath has turned to organic farming to find his niche in the commercial farming world. Farming has changed, and so has the price of land. (Author's collection.)

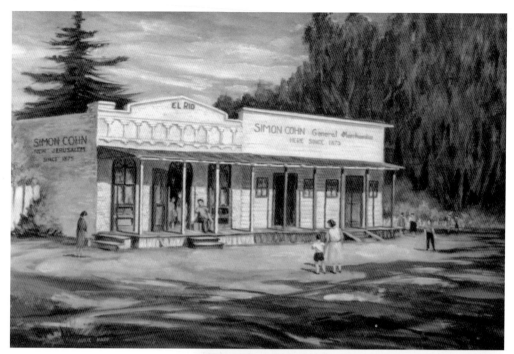

Simon Cohn

Simon Cohn was the unofficial mayor of El Rio. Originally called "New Jerusalem," the area was, according to historian E.M. Sheridan, first settled in 1868 by a religious sect called the Disciples of Christ. Cohn established a mercantile store in 1875, as well as a post office under the name New Jerusalem. In 1895, the post office's designation was changed to simply "Jerusalem." A few months later, it became "Elrio" before finally being corrected to El Rio. Cohn was able to take on loans from many of the farmers who needed supplies. He kept impeccable records, except on one occasion when he made a sale but forgot the customer's name. He sent out a bill to 30 clients, hoping the buyer would step forward. However, the problem was multiplied when 29 of the 30 sent in payment. (Painting by Junie Harp; photograph courtesy Ed Roebings.)

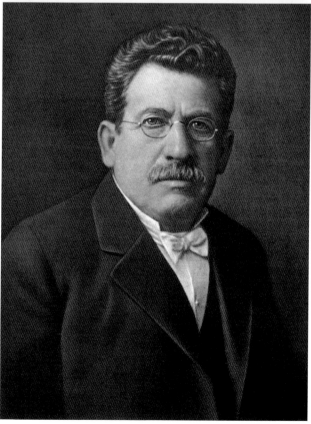

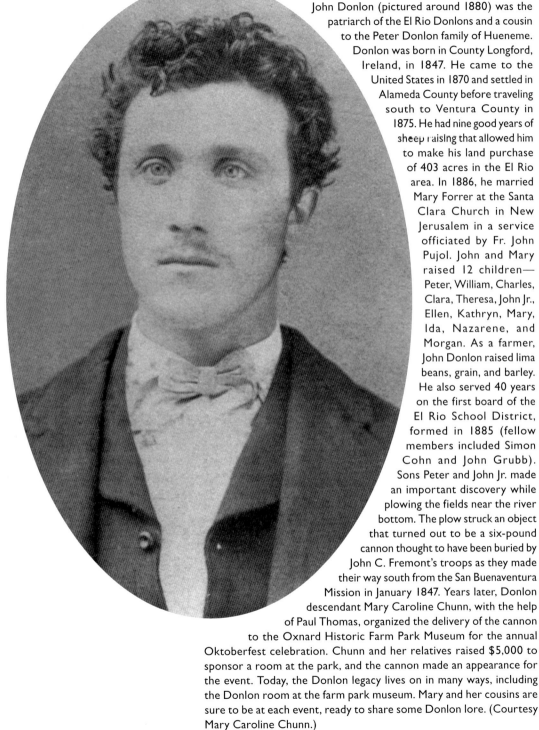

John Donlon

John Donlon (pictured around 1880) was the patriarch of the El Rio Donlons and a cousin to the Peter Donlon family of Hueneme. Donlon was born in County Longford, Ireland, in 1847. He came to the United States in 1870 and settled in Alameda County before traveling south to Ventura County in 1875. He had nine good years of sheep raising that allowed him to make his land purchase of 403 acres in the El Rio area. In 1886, he married Mary Forrer at the Santa Clara Church in New Jerusalem in a service officiated by Fr. John Pujol. John and Mary raised 12 children— Peter, William, Charles, Clara, Theresa, John Jr., Ellen, Kathryn, Mary, Ida, Nazarene, and Morgan. As a farmer, John Donlon raised lima beans, grain, and barley. He also served 40 years on the first board of the El Rio School District, formed in 1885 (fellow members included Simon Cohn and John Grubb). Sons Peter and John Jr. made an important discovery while plowing the fields near the river bottom. The plow struck an object that turned out to be a six-pound cannon thought to have been buried by John C. Fremont's troops as they made their way south from the San Buenaventura Mission in January 1847. Years later, Donlon descendant Mary Caroline Chunn, with the help of Paul Thomas, organized the delivery of the cannon to the Oxnard Historic Farm Park Museum for the annual Oktoberfest celebration. Chunn and her relatives raised $5,000 to sponsor a room at the park, and the cannon made an appearance for the event. Today, the Donlon legacy lives on in many ways, including the Donlon room at the farm park museum. Mary and her cousins are sure to be at each event, ready to share some Donlon lore. (Courtesy Mary Caroline Chunn.)

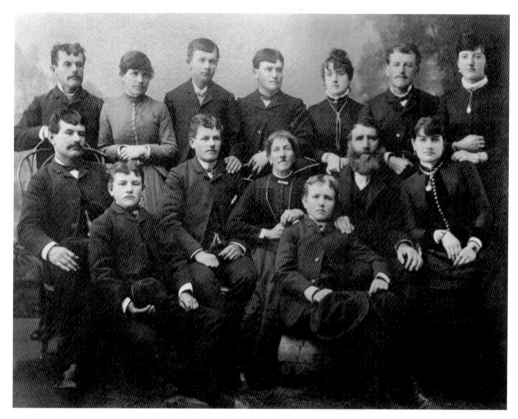

The Gisler Family

The Max and Josephine Gisler family came to the United States in waves. First came Max and Sigmund in 1876; followed by Mary and Leopold; then Samuel, Solomon, and Gabriel; and, finally, Edmund, Hannah, Max Jr., Josephine, Frank, Joe, and Theresia. Max Gisler's first land purchase was of six acres in New Jerusalem, which he bought from Christian Borchard. The family built a two-story home next to the Santa Clara Church, with a saloon at the other end of the property. Gabe Gisler bought 90 acres in Springville (Camarillo) and married Margaret Riemann. Frank and Joe Gisler purchased 157 acres at Gonzales Road and Oxnard Boulevard, and Ed and Sam Gisler purchased land in the Camarillo Heights. Theresia Gisler married Charles J. Dailey, and Samuel Gisler married Katherine Cloyne. Pictured left is Stan Gisler farming Cloyne ranch in 1949. Samuel's son Leo married Katherine Cloyne. Leo's son Stanley continued the farming tradition, pictured taking a break on the Cloyne Ranch. (Author's collection.)

Thomas Cloyne

Thomas Cloyne was born in County Longford, Ireland, in 1840. He came across the overland route to California 1866 and joined up with his sister Catherine, who was married to Peter Donlon. Cloyne was hired to drive Donlon's sheep to property he had purchased from Thomas Bard in 1869. Cloyne walked to Ventura County from Northern California with a herd of sheep and helped set up the ranch. Cloyne was appointed to the San Pedro Road District, the area that encompassed the Oxnard and Hueneme areas. His job was to establish the first roads in Oxnard. He was also part of the building committee for the Santa Clara Church in New Jerusalem, established in 1877. He was continuously adding to his holdings, expanding his original ranch off Saviers Road from 139 acres to 300 acres. He added another 700 acres in Las Posas, which he largely devoted to growing lima beans. (Author's collection.)

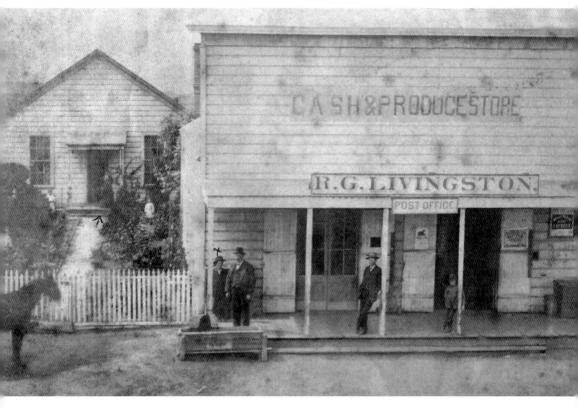

Dr. William Livingston

People from all around the world traveled to Oxnard, California, just to have Dr. Livingston deliver their babies. William Reinhardt Livingston was born in 1870 in Wynema (Port Hueneme), California. He was a grandson of Robert R. Livingston, who helped draft the Declaration of Independence and, as chancellor of New York, administered the presidential oath of office to George Washington. Dr. Livingston earned his medical degree in 1893 from the College of Physicians and Surgeons of Chicago. Later, he served as a physician in the Mexican Railroad Hospital in Tampico, Mexico. He and his family settled back in Oxnard shortly after the turn of the century, and by 1908 he had a growing medical practice. He opened a hospital on B Street with Drs. A.A. Maulhardt and R.D. Potts. In 1914, Dr. Livingston began what would be the most significant part of his medical career when he traveled to Europe on a fellowship from the American College of Surgeons. In Freiburg, Germany, he spent time with Dr. Carl Gauss learning about a new child-birthing method called "twilight sleep." The development involved replacing the use of chloroform with a combination of morphine and scopolamine for a pain-free childbirth. When Livingston returned to St. John's Hospital, he was one of the first doctors in the nation to use the method, and he therefore became a mentor in the practice. Pictured is his grandfather Robert Livingston's mercantile store, around 1890. (Courtesy Marcia Donlon.)

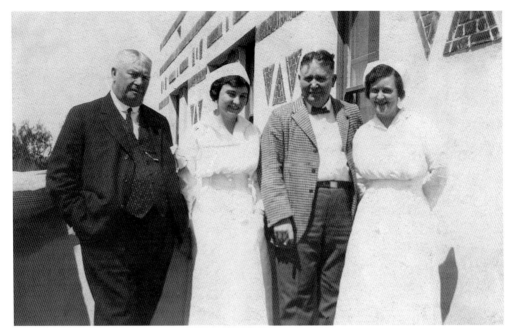

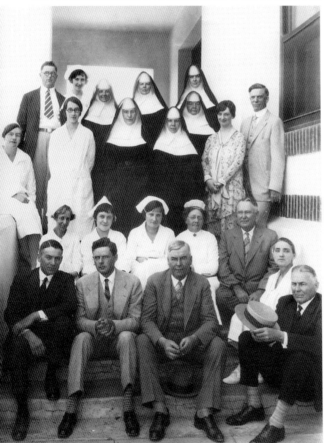

A Lasting Legacy

After Dr. Livingston retired in 1933, he began experimenting with avocados, coming up with 27 different varieties. He had previously helped establish the citrus industry by planting the first lemon orchard in 1910. Livingston died in 1952, but his legacy lives on through the Livingston Memorial Foundation, established in 1974. In 1980, the Livingston Memorial Visiting Nurse Association was formed out of the Visiting Nurse Association and funded by the Livingston Memorial Foundation. Dr. Livingston's contributions were summed up by a quote from the Sisters of Mercy: "We all feel that the name of Dr. W.R. Livingston, one of the chief benefactors of our hospital, should be written in golden characters in the Annals, instead of in these few lines." Pictured above, around 1930, are Dr. Maulhardt (left) and Dr. Livingston with two nurses. The photograph to the left is of the St. John's Hospital staff around 1927. (Courtesy Marcia Donlon.)

James Alexander Driffill

As the right-hand man of the Oxnard brothers and superintendent of the American Beet Sugar factory, James A. Driffill not only helped supervise the construction of the sugar factory, he laid of the plans for the town of Oxnard. Driffill was born in Rochester, New York, on September 24, 1859. While in New York, he joined the National Guard, advancing to the rank of captain. After relocating to California in 1883, he joined Company D of the 7th California Regiment and was promoted to lieutenant, then major. In 1898, he used the factory warehouse in Oxnard for a company of volunteers during the Spanish-American War. While living in Pomona, Driffill began a nursery for oranges and other products. His business struggled, but then an opportunity arose to work as a revenue officer for the government. One of his duties was to determine the number of pounds of sugar at the Oxnard brothers' factory in Chino. When the job ended, he was offered a position at the Chino factory, where he worked his way up to manager. When the plans for a new factory in Ventura County came up, Driffill was assigned to supervise. He set up the Colonia Improvement Company and purchased 31 acres from John Hill for the townsite, as well as an additional 133 acres for growth. The company also built the Oxnard Hotel and established the Bank of Oxnard. In addition, Driffill organized the Oxnard Light & Water Company, actively participated in the Board of Trade, and served on the original building committee for St. John's Hospital. A booster club song was created for the campaign based on the Civil War song "Marching through Georgia." The new lyrics included the line "Major Driffill never led a weak or losing game." Though he fell ill later years, Driffill kept in contact with the factory on a daily basis. In March 1917, Maj. James A. Driffill passed away in his rocking chair while awaiting a visit from his longtime friend and colleague Joseph Sailer. Upon his passing, the *Oxnard Courier* printed, "He was the founder and hearty supporter of every movement and of every enterprise that had for its object progress and betterment. He was Oxnard's most precious asset." One of the city's first streets is named for him, as is an elementary school. (Author's collection.)

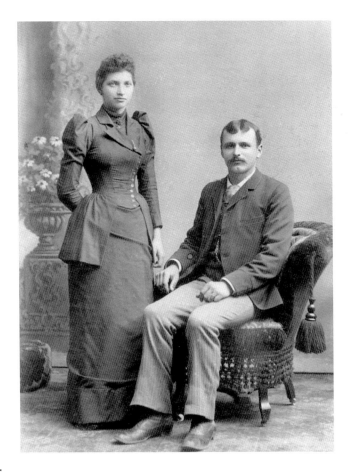

Joseph Sailer

From immigrant to mayor, Joseph Sailer made the climb to the top position in Oxnard. Sailer was born in Prutz, Austria, in 1867. He traveled to America at 14 and landed in Chicago, where he apprenticed as a machinist for three years. In 1886, he traveled to California and found a job as a mechanic with the American Refinery Company in San Francisco, where Robert Oxnard worked. After the refinery closed in 1891, Sailer was transferred to the new Sugar Factory in Chino, where he helped install the new machinery. Sailer married Katie Schoeffel, and the couple raised three children—Katie, Joseph, and Carl. In 1897, Sailer was sent to Ventura County to oversee the construction of the sugar factory in Oxnard. When he arrived in the fall, he stayed in a bunkhouse that had been built on the factory grounds, which qualified as the first home constructed in the area in connection with the development of the city of Oxnard. Sailer's job title at the Oxnard factory was master mechanic, but by 1915 he was appointed superintendent. Sailer jumped into the political arena in 1908 when he joined the city trustees, and on April 19 he began his 10-year appointment as mayor. It was under his tenure that the city made tremendous progress in establishing itself as a first-rate city. With his experience as an engineer, he helped design the city's water and sewer systems. He also set a curfew for saloons to close down at 11:00 p.m. He was greatly influential in the construction of the historic downtown pagoda that served as both a cover the water system at the park and, after the 1911 addition of a middle story, a bandstand. Sailer was also responsible for the 1915 decision to up the police force from one to four. Retired by 1920, he would enjoy another three decades at his Simi Valley ranch, where he raised lemons and oranges. This did not stop his weekly visits to Oxnard to attend services at Santa Clara Church and enjoy a family dinner at one of his children's homes. Joe Sailer accomplished the American dream by working hard and literally enjoying the fruits of his labor. (Author's collection.)

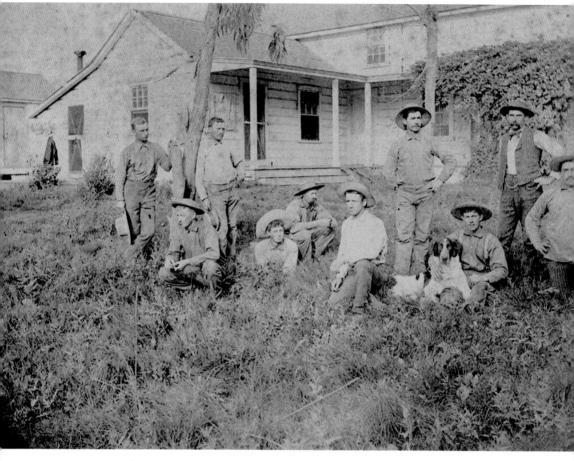

Herbert H. Eastwood

Herbert H. Eastwood was born in England and came to the area in 1876 with his parents, George and Felicite Eastwood and his siblings—George, John, Ernest, Walter, Thomas, Louise, Alice, Grace, James, and Frank. The family settled in the New Jerusalem (El Rio), where George set up shop as a cabinetmaker and upholsterer and took turns with Felicite serving as the postmaster. Herbert joined his brother George as a cowhand for the Patterson ranch, earning $35 a month. He bought 400 acres in the Ocean View district and then joined in partnership with J.W. Shillington, who operated the Oxnard Implement Company. By 1909, Eastwood joined the city council, and in 1920 he was elected mayor. Eastwood sold his implement business to Paul Norman in 1919 and opened a real estate business. In 1925, when there was talk of the sugar factory leaving town, Eastwood negotiated 18 large tracts of farmland to sell to the factory to ensure that beet production would be sufficient. Eastwood also joined the Harbor District Board in 1940 before returning to a two-year term as mayor in 1942. He retired in 1944. Here, he is pictured with cowhands at Patterson ranch in the 1890s. (Courtesy Eric Daily.)

Joseph Laubacher

Joseph Laubacher was born in Malvern, Ohio, in 1874. He was one of nine children of George and Anna Gang Laubacher, with siblings including John (a future reverend); Frank; Daniel Benjamin; Edward George; Margaret; Bernadine; Stella; and William Louis, who died in infancy. Father George was from Alsace-Lorraine, France (which alternated between French and German rule for most of its history), but had been brought to the United States as an infant. As an adult, he was a contractor and then a farmer in Ohio. It was in Ohio that Joseph learned the trade of barbering. He moved to Los Angeles for a year in 1900 and, in 1901, followed his brother Rev. John Laubacher to Oxnard. He opened a barbershop in the new brick Levy building in 1902 and stayed there for four years before joining Thomas Hill's real estate and insurance business in 1907. He took on the insurance side of the business, buying out Hill in 1917, and his family has carried on the business for over 100 years. Joseph also joined his brothers in their farming ventures. In 1910, they bought 62 acres from H.K. Snow. They sold the property and, 10 years later, purchased 430 acres of the Patterson ranch. Their early crops included lima beans, sugar beets, and alfalfa. Joseph's son Thomas Edward "Tom" Laubacher followed in his father's footsteps, but not before putting in several years of farming at the family's ranch off Doris Avenue and Teal Club Road. Tom served in the US Army from 1941 to 1944 as a B-26 pilot instructor and returned home to work for Union Oil Co., where he had previously been employed. By 1947, he joined his father's business, Laubacher Insurance & Real Estate. Tom added Ventura County supervisor to his list of duties, serving the community from 1965 to 1981. His list of accomplishments is too long to list here, but the legacy of the family business lives on. Tom's son Tom Jr. became the third generation in the Joseph Laubacher family to run the company, helping to make it the oldest business in Oxnard, with over 100 years of service. (Courtesy Barbara Laubacher.)

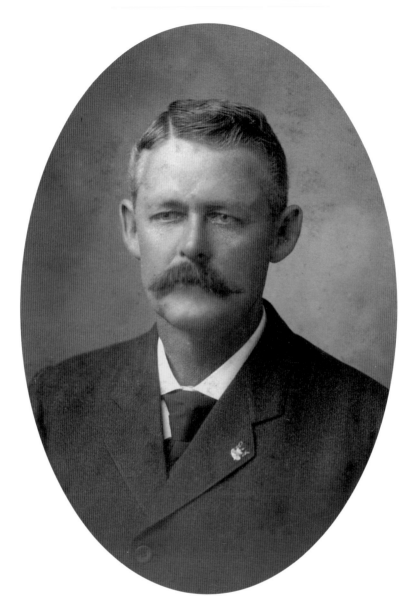

William Cooper, from Pennsylvania to Cooper Road
The Cooper family's roots in California date back to 1870, when Ellwood Cooper joined Col. William Hollister in the Goleta area. Cooper was a horticulturist from Pennsylvania, and here he envisioned an olive industry to rival Italy's. He purchased 400 acres and planted 7,000 olive trees and 12,500 walnut trees, becoming the largest producer of each in the United States. He also became the first commercial propagator and distributor of eucalyptus in California. At the peak of propagation, Cooper had over 150,000 blue gum seedlings. Soon, the blue gum eucalyptus made its way to Ventura County, as did Ellwood's nephew William B. Cooper. William was born in Pennsylvania in 1856. His father died during the Civil War, and by his teen years William was working in a steel mill. He came out west to work for his uncle in Goleta. In 1881, he married Harriet "Hattie" Simmons, and they moved to Los Angeles for a few years before relocating to a ranch near present-day Cooper Road at Del Sol Park. (Courtesy Carrie Pell Dominguez.)

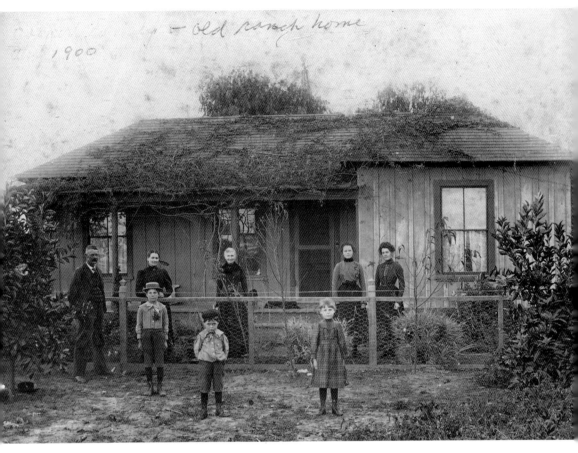

Farming, Public Service, and Business

In addition for farming lima beans, William Cooper served in several public offices, including tax collector and justice of the peace for the township of Hueneme, which includes present-day Oxnard. Cooper was also a census officer, and his name appears at the top of the 1900 census. In 1901, Cooper formed a partnership with Thomas Ruiz and Edward Abplanalp to establish the Oxnard Electric Supply Company. He also served as a representative with Louis Brenneis and was one of Oxnard's first insurance agents. Representing the east county, Cooper sold insurance for the Ventura County Mutual Fire Company, which was incorporated in 1898 and, after several mergers, became part of California Capital Insurance. He set up office at 234 Fifth Street. William and Hattie had five children. Their youngest son, Robert, served as a corporal during World War I and was killed in France. Their other children included Mary (Jones), Estelle (Poggi), Elwood, and Effie (Pell). (Courtesy Carrie Pell Dominguez.)

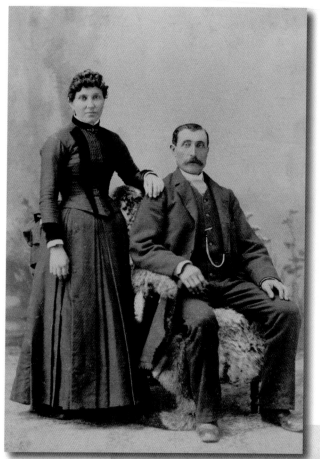

Mary Kaufmann
The sisters' parents, Michael and Mary Kaufmann, arrived in Ventura County in 1868 and purchased 160 acres from Thomas Bard. The property was located at the corner of Oxnard Boulevard and Gonzales Road. In 1871, the Kaufmanns' property was chosen as the site of the first school in the area, San Pedro. Michael Kaufmann asked Ed Borchard to go to Ventura with him to take care of some business, and Ed became acquainted with Kaufmann's daughter Mary, marrying her when she was 19 years old. Ed and Mary are pictured below. Left are Mary's sister Caroline Kaufmann Pfeiler and her husband, Louis. (Both photographs, author's collection.)

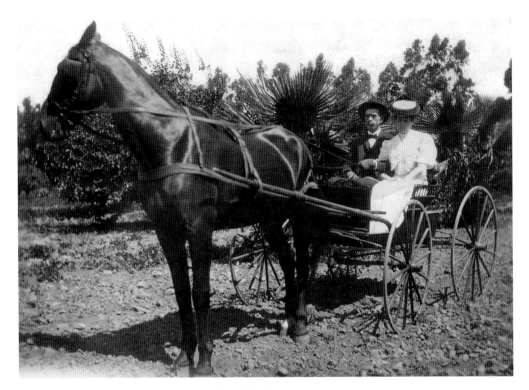

Catherine, Caroline, Frances, and Lizzy Kaufmann

Mary Kaufmann's sister Catherine married Fridolyn "Fred" Hartman, who owned Hartman's Brewery and, later, the Anacapa Hotel. Hartman used to deliver kegs of beer to each of the ranches throughout the county. As Henry Borchard recalled years later, "We thought no more about getting a glass of beer than getting a drink of water out of the faucet." Caroline Kaufmann married Louis Pfeiler, and sister Frances Kaufmann wed Justin Petit. The Kaufmann property was divided into 78-acre parcels. Lizzy Kaufmann, excluded from the process, moved away from the Oxnard area. The remaining sisters, however, stayed nearby, raising large families that have contributed to a legacy of the Kaufmann descendants. Pictured above are Frances Kaufmann Petit and her husband, Justin. Below, Catherine Kaufmann Hartman is shown with her husband, Fred, and family. (Both, author's collection.)

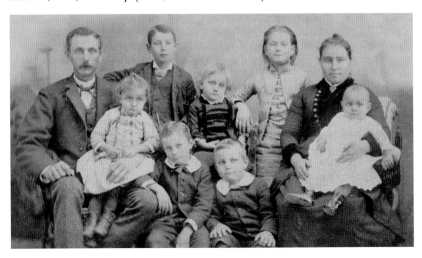

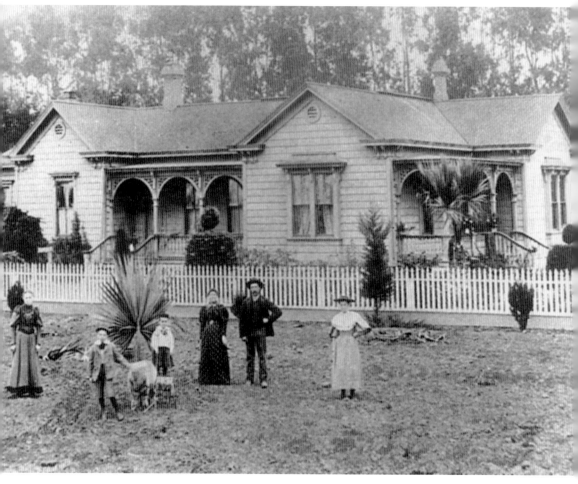

Bob Pfeiler, Early Years

Robert "Bob" Pfeiler was a man of many talents. He was an athlete in his youth and went on to be a photographer, a public servant, a farmer, and a beloved husband and father. He combined his lifelong experience in and love for farming to help establish the Agriculture Museum in Ventura County. Bob was born on October 20, 1910, to Albert and Lydia Pfeiler. His grandparents were pioneers Louis and Caroline Kaufmann Pfeiler. Caroline's father, Michael Kaufmann, arrived in the area in 1868. Austrian-born Louis Pfeiler made his way to New York in 1866 and worked his way out west by 1868. Louis and Caroline raised six children—Albert, Bertha, Josephine, Rudy, Hulda, and Emil. Oldest son Albert was given a 30-acre ranch as a wedding gift in 1904. The ranch had previously belonged to Gottfried Maulhardt's widow, Sophie, and was located next to a 75-acre property that belonged to Caroline. Albert and Lydia raised their three children, Florence, Ralph, and Bob, at the ranch. The two adjoining properties were combined, and Bob continued to farm the now-105-acre ranch. A portion was sold to the Oxnard School District and used for the Brekke School. Bob, who retired from farming in 1998, lived a well-rounded life. An amateur photographer (he even had his own darkroom), he captured many county images from the 1930s through the 1960s. He was also a sportsman, competing as part of the 1926 Oxnard High School undefeated tri-county basketball champs. He later organized his friends to take up the new sport of waterskiing, even helping to reinforce the banks of the flooded area known as McGrath Lake so he could use his speedboat and wooden skis. He was also a charter member of the Ventura County Yacht Club. (Author's collection.)

Bob Pfeiler Looks to the Future

Bob Pfeiler was a board member for the Oxnard School District and, in 1957, became president of the Ventura County Historical Society. By 1972, Bob started collecting old tractors and implements. He formed a committee that eventually totaled 18 like-minded enthusiasts, and they began a fundraising crusade. Working with the Ventura County Museum, the Agriculture Museum landed in the historic Mill building adjacent to the Southern Pacific Railroad station in downtown Santa Paula. The museum owns nearly 1,000 items, including clothing, periodicals, photographs, and other unique artifacts. In 2001, Bob's ranch sold to developer John Laing Homes. The Oxnard Historic Farm Park Foundation was formed to take on the task of preserving the original buildings as well as to create the Oxnard Historic Farm Park Museum. Pictured right is the Albert and Lydia Pfeiler family, and below is Bob Pfeiler with his daughters. (Both photographs, courtesy Bob Pfeiler.)

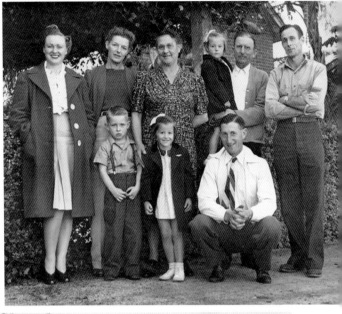

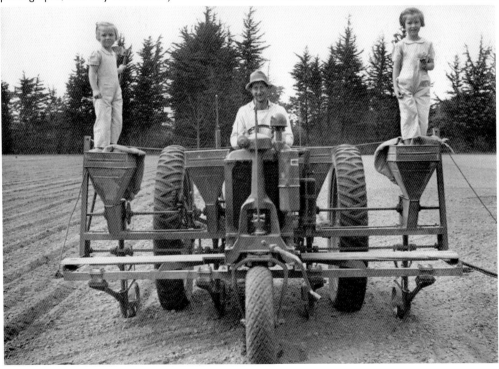

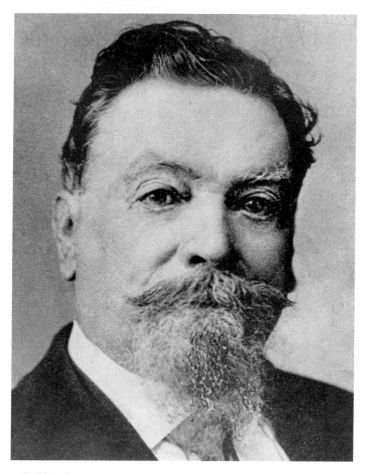

Covarrubias to California

Some local legends, like Charles "Chuck" Covarrubias, have legendary roots. Chuck's great-great-grandfather Jose Maria Covarrubias arrived in California when Oxnard was still a deserted plain. Born of French ancestry in 1809, he came to California with the Hijar Padres Colony in 1834 and ended up in Santa Barbara with Juan Camarillo. Covarrubias married Maria Carrillo, the granddaughter Don Raymundo Carrillo (one of the first commanders of the Santa Barbara Presidio). He served as the alcalde—a dual judicial and administrative position—for the Santa Barbara Mission. In 1847, Jose and his wife took up residence in the adobe built by Maria's father, Don Dominguez Carrillo. The Covarrubias family lived there for over 50 years, and the adobe survives today at 715 Santa Barbara Street as a registered historic landmark. Jose applied for several land grants and received the grant for Rancho Castac (which later became the Fort Tejon area) in 1843. He and brother-in-law Joaquin Carrillo were also granted the 26,634-acre Rancho San Carlos de Jonata (located west of Mission Santa Ines) in 1945. Additionally, Covarrubias purchased the land grant for the Island of Santa Catalina from Thomas M. Robbins, which he sold a few years later. One of Covarrubias's most important roles was that of member of the 1849 California Convention. He was joined in this function by Henry Carnes, his son's father-in-law. Covarrubias was a member of the California State Assembly for four terms, from 1849 to 1862, and was the first federal elector from American California. His oldest son, Nicolas Covarrubias, became an excellent horseman, which served him well when he became sheriff of Santa Barbara in 1870. Youngest son George Washington Covarrubias married Mary Carnes, and they lived in Los Angeles for several years before Mary (without husband) and her children returned to Ventura County to live in a home on the Camarillo ranch (now the site of the Camarillo High School). (Courtesy Florence Obiols Maulhardt.)

Covarrubias to Oxnard

Representing the next generation was Charles John Covarrubias. He found a job in Hueneme working at John Steinmiller's harness shop. Upon retiring, Steinmiller left the shop to Charles and Bill Bright. The harness shop became a one-stop shopping experience for outdoorsmen, providing guns, ammunition, and fishing gear. Charles's son Charles "Mason" Covarrubias joined him in the business for a time before taking a position at Oxnard Frozen Foods. He stayed active for several more decades and was on hand in 2003 to celebrate the city's 100th anniversary as grand marshal for the parade. Mason's son Chuck graduated from Oxnard High School in 1955. During his senior year, Chuck worked at the sugar factory. He went on to attend California Polytechnic State University before returning to Ventura County, where he drove a tractor for Herman Becker and Harold Bell at the Camarillo ranch. As much as ranching was in his blood, so was the thought of a fine cigar, a steak anytime he wanted, and a nice Cadillac. Chuck was taking a time-out at the Colonial House restaurant when he was invited by Joe Kerrick to visit his real estate office. In 1968, Chuck formed Alert Realty with Marsh Thulin. They split in 1972, but Chuck was joined by another partner, Ed Paul, in 1988, and the business became Alert Management. In recent years, Chuck's son David has taken over the business. In 1967, Chuck, along with Ron Seymour, helped form the Ambassadors, a service group that operates as an arm of the Oxnard Chamber of Commerce. This group has helped bring together the many varied groups in the community to help establish a better understanding of each other in a nonthreatening social setting. Chuck has also served many years on the board of the Ventura County Museum of History and Art, which led to a request from Oxnard farmer Bob Pfeiler to help collect farm implements for a future farm implement museum. Other groups to which Chuck has volunteered his time have included the board of the St. John's Foundation and the Oxnard Historic Farm Park Foundation. Chuck is pictured here at Oxnard Historic Farm Park Museum. (Author's collection.)

Naumann Beet Roots

The Naumann family in the United States traces its roots back to Samuel Ernst Naumann. Born in Atzendorf, Germany, Samuel traveled on the 8,000-horsepower steamship *Ems* that traveled across the Atlantic at 16.5 knots. Making the trip with Samuel were his wife, Rosina Wilcke, and children Herman, Louise, Emma, Paul, Otto and Gus (ages 2 to 11). They eventually made their way to Victoria, Texas, where a population of 125,000 Germans was already making a go at farming the virgin Texas soil. In 1891, Samuel purchased 104 acres near Germantown (present-day Schroeder). By 1893, the family (which now included daughter Martha) relocated to Chino, California, home of the recently constructed sugar factory. By October 1895, Samuel is mentioned in the local paper for delivering beets to the factory. By 1898, sons Otto and Paul were working in Ventura County with the construction crew that built the factory in Oxnard. Paul stayed on to run the pulp engine at the factory, and the rest of the Naumann family settled in the Ocean View area. By 1901, the Naumanns were here to stay. Samuel purchased 159 acres from Charles Etting for $14,000, and in 1904 he bought another 80 acres. He also helped establish the German Lutheran Church, located at Seventh and C Streets, in 1901. The Naumann brothers all took their turn at farming. In addition to sugar beets, the brothers also grew lima beans. The beans were threshed, sacked, and loaded on a wagon to be delivered, while the beets were pulled from the soil, topped, and loaded in a wagon that was driven to a beet dump—an elevated ramp along the rail line where the wagon could dump the beets in a railcar (the Naumann Beet Dump was off Etting Road, near Wood Road). Always looking to improve their farming conditions, Gus Naumann teamed up with A.C. Lodwig in 1908 and came up with an adjustable bean cultivator. The mechanical gene was also apparent in Gus's brother Paul, who owned and operated Naumann's Machine Shop at 319 Third Street. (Courtesy Frank Naumann.)

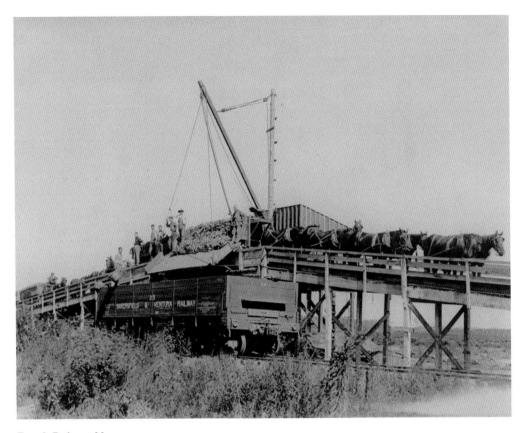

Frank Robert Naumann

Frank and later generations of Naumanns have continued farming into the present. Robert Naumann, grandson of Samuel and father of Frank, had the family history recorded into a self-published book, *Ocean View Odyssey*. Frank expanded on the early years of the family history in his own detailed self publication.

He has not only taken the time to collect and reflect on the past, he has made it his duty to preserve history by establishing the Frank Naumann Local History Library at the Oxnard Historic Farm Park Museum. Frank Naumann's ranch home is a museum to his youth, as well as to his family's roots. Pictured above is the Naumann Beet Dump. At right, Frank Naumann is pictured inside the Naumann room at the Oxnard Historic Farm Park Museum. (Top, courtesy Frank Naumann; right, author's collection.)

Gary Edward Blum

The roots of the Petit and Kaufmann families date back over 140 years. It has been the many efforts of Gary Blum that have not only preserved his families' legacies, but the history of many other branches of the county's history. Blum is a fifth generation decedent of the Petit and Kaufmann farming families of Oxnard. He has been involved with historic preservation since the mid-1980s, when he relocated and restored the Petit family home for Oxnard's Heritage Square project. Gary became a consultant, providing services in property management and maintenance, special event planning, and marketing. Gary was a contract manager for the Camarillo Ranch from 2001 to 2003 and, beginning in 1995, he was contracted with the City of Oxnard to oversee summer concerts and private events at Heritage Square. He has served as the Square's site superintendent and been involved with the Ventura County Cultural Heritage Board, Downtown Oxnard Merchants Association, Oxnard Downtown Management District and the Oxnard Performing Arts & Convention Center, and the Oxnard Historic Farm Park Foundation. For the past three decades, if it has concerned history or the arts in Oxnard, it is most likely that Gary Blum has had a hand in helping or directing it. (Courtesy Gary Blum.)

CHAPTER TWO

Groundbreakers

Literal and figurative groundbreakers make up this chapter of biographies. From Albert Maulhardt, who conducted the two-year sugar beet experiment to bring the sugar factory to the area, to John Laubacher, who did so much to bring about a school, a church, and a hospital. From Achille Levy, a Jewish immigrant who started the area's first bank, to Martin Smith, who built the first high-rise building. All of these groundbreakers made major changes in Oxnard. Joseph and Annie Friedrich gave a legendary amount of land and money to help provide parochial education and a place of worship for thousands of residents on "both of the tracks," following in the footsteps of Annie's father, Johannes Borchard, who had given an unprecedented amount of money in his day to help establish St. Johns Hospital. Groundbreakers in the field of agriculture included both the Hiji brothers and the Dullam Nursery, carrying on the tradition of farming after World War II and bringing the next successful crops to the area. Groundbreakers in the restaurant business are represented with the biographies on the Lopez and Otani families. While Cesar Chavez helped organize the growing Mexican voice in Oxnard, people like Sal Sanchez benefited from his efforts politically. Later-day groundbreakers like Armando Lopez helped bring about some of Oxnard's more upscale and thought-out developments. These legends and more make up the groundbreakers in Oxnard.

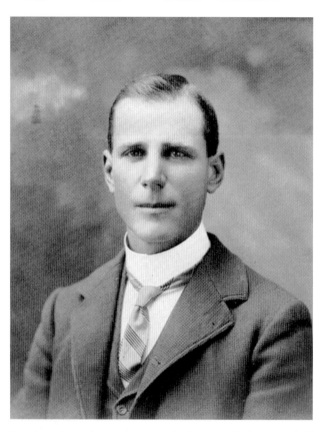

Introduction to the Sugar Beet, Albert Francis Maulhardt

Albert F. Maulhardt was a man who dreamed of doing something big. No dream was more ambitious than what he did accomplish: luring the Oxnard brothers to build the $2-million sugar factory that ultimately led to the establishment of the city of Oxnard. Maulhardt was born in 1872. His 400-acre ranch was near present-day Ventura Road and Channel Islands and stretched toward the Center Point Mall and Santa Clara High School. He was educated at St. Vincent's College, where he attended with Henry Borchard. Henry's father, Ed Borchard, raised a strain of sugar beets from Germany that he used to feed his livestock. Albert and Ed decided to take a load of beets to the sugar factory in Chino. While the sugar content was low, the men were given some company seeds, which they brought back to Ventura County. At this point, 1896, Albert took the lead, signing up dozens of local farmers and securing over 200 locations throughout county, each planted with between half an acre and five acres. He also used a steam-powered tractor, the first in the area, to help get more work done in less time. The results were impressive. The sugar content was as high as 32 percent, well above the required 18 percent needed to process sugar. The Oxnards required a second season of planting to duplicate the results and made several other demands, as well. After a second successful year of plantings, the Oxnards had a few more stipulations, including 5,000 gallons of water needed for processing the beets, a bridge across the Santa Clara River, and a rail line to the factory. Albert's crew drilled seven wells to meet the request for a water source, then turned to the county supervisors to sponsor a bridge between Oxnard and Ventura. Albert recruited Thomas Rice and Ed Borchard to put up the money and the crews to drive in the pilings for the bridge; from that point, the supervisors could not say no. With the bridge came the spur line to the factory. The land for the factory was also a result of Albert's negotiations. He got the local farmers to underwrite the cost of the 100 acres, which were purchased from Thomas Rice and had previously been part of the former Saviers ranch. The sugar company paid for the land and collected later from the farmers by deducting 15¢ from each ton of beets. Albert was able to show the local farmers that, after expenses, they could expect to make between $34 and $70 an acre, making beets far more lucrative than any other crop grown in the area. Ground was broken by December 1897, and by August 1898 the factory was complete. At this same time, the Oxnards purchased land under the investment firm Colonia Improvement Company and an adjoining townsite began to grow out of the former ranch of Jack Hill. (Author's collection.)

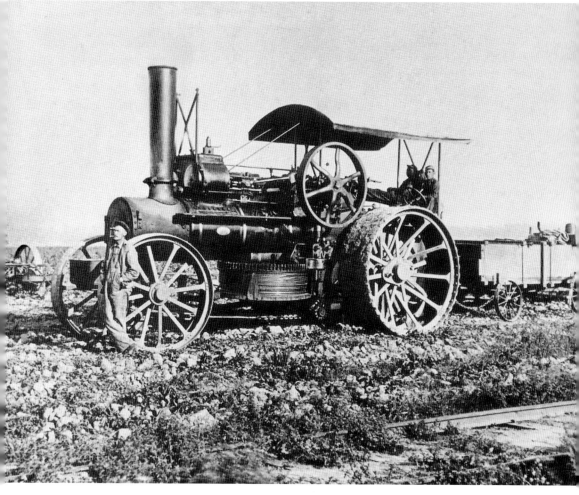

Beyond the Beet

Albert married Jenny Buell, daughter of the prominent Buell family from Santa Barbara, and the couple had two boys, Vincent and John ("Jack"). They spent their early years in Oxnard, but when the boys were in their early teens, they returned with Jenny to Santa Barbara. Albert attempted several more projects, including investing in a silver mine in Mexico (which he lost to the Mexican Revolution). He also attempted to develop a citrus industry in the Camarillo Heights. He created a syllabus of all the assets in the area; conducted scientific experiments to demonstrate that the mountainside was impervious to freezing; formed the Pleasant Valley Lemon Company and then sold it to a Los Angeles investor (a transaction reported in the *Oxnard Courier* as the "Biggest Lemon Deal in History of California"). However, the deal was predicated on getting water to the young trees. Albert set up a water-pumping plant on the edge of the Oxnard Plain, but he needed the right-of-way to pump the water to the site. Unfortunately, he fell one approval short because of an insufficient water source. He next turned to subdividing the lots into small ranches, but plans were permanently sidetracked when he fell victim to a stroke at age 54. When he passed away in November 1925, the headline from the *Oxnard Courier* said it best: "Community Loses One of its Biggest Boosters in Death of A. Maulhardt." Not all of his dreams came to fruition, but his efforts to bring a cash crop to the area led to the development of Oxnard. Pictured is Albert's steam-powered tractor. (Courtesy Juan Garza.)

The Oxnard Brothers

Many have wondered at the origin of the name *Oxnard*. While some may know that the name came from a family, its origin remains mysterious. Is the name French? German? Spanish? Scandinavian? Guess again. The name derived from the English *Oxenherd*, short for "oxen herder." The Oxnard family's connection to sugar processing dates back to 1839, when Thomas Oxnard IV married Louise "Adeline" Brown, whose father, William Brown, grew sugar cane in New Orleans. Thomas Oxnard IV was born in France, though his father, Thomas Oxnard III, was born in Maine. The family had moved to France after the War of 1812, but Thomas Oxnard IV returned to America and settled in Boston. Seeking a milder climate, the 21-year-old went to live with his uncle Henry P. Oxnard in New Orleans, where he met his bride and joined her father in the sugar business. Soon, Thomas Oxnard owned three sugar plantations, as well as the Louisiana Sugar

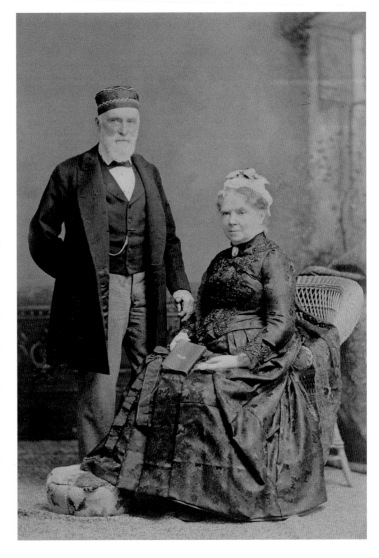

Refinery of New Orleans. He and Adeline had six children, including the four brothers who would help establish the factory and town of Oxnard. Eldest sons Robert and Benjamin were born in 1853 and 1955, respectively. With the Civil War on the horizon, Thomas Oxnard sold his sugar interests and moved to the home of his mother in Marseilles, France, where son Henry Thomas Oxnard was born on June 22, 1860. The family returned to Boston the following year, and fourth son James Guerrero Oxnard was born. The same year, Thomas built the Oxnard Sugar Refinery in Boston. He sold the business after seven years and purchased the Fulton Refinery in New York. Robert Oxnard, after spending five years in Cuba learning the sugar business, contributed his experience to help increase the production. Benjamin attended Massachusetts Institute of Technology and added his expertise in chemistry to the family business. Henry T. Oxnard graduated in 1882 from Harvard (where he crossed paths with Theodore Roosevelt, the future president and antagonist to the sugar monopoly that would develop in later years). James graduated from Columbia and, like Benjamin, focused on chemistry. Pictured are Thomas Oxnard IV and Adeline Brown Oxnard, parents of the Oxnard brothers. (Courtesy Henry and Thornton Oxnard.)

46

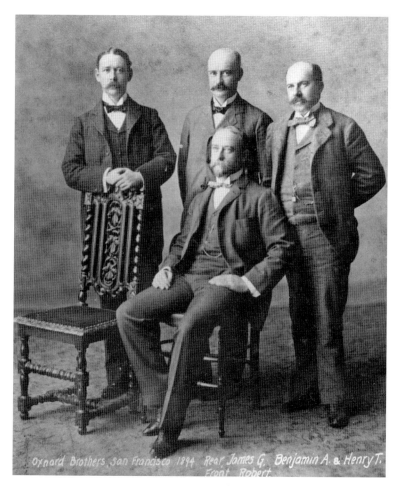

Oxnard Brothers, San Francisco 1894 Rear James G. Benjamin A. & Henry T. Front Robert

The Oxnards in Oxnard

It was Henry T. Oxnard who saw the potential of devolving the beet sugar industry because the beet could grow in a variety of environments. He traveled to Europe to study the industry methods used by the French and Germans. Henry and James Oxnard lobbied extensively for favorable legislation to help launch the beet sugar industry. In 1890, the McKinley Tariff not only offered a 2¢ bounty per pound of sugar to encourage the farmer to grow the sugar beets, Congress also waived the import tax on beet sugar machinery, allowing the Oxnards and their investors to build two factories in Nebraska and one in Chino, California. Henry Oxnard worked in another bit of legislation that became the Dingley Tariff of 1897. This put a tax on imported sugar and gave the Oxnards their second wind to build several more factories, including the Oxnard facility, which was running by 1899 and was followed by factories in Rocky Ford, Colorado (in 1900), and Las Animas, Colorado (1907). All four Oxnard brothers invested in a sugar refinery in Louisiana, which they named the Adeline Sugar Factory in honor of their mother. Benjamin Oxnard branched out from the family in 1915 and started the Savannah Sugar Refinery in Georgia. He married Robbie Giffen and had two sons, Benjamin and Thomas, who took on positions in the business. Ironically, while Benjamin did not invest in the Oxnard factory, his descendants stayed in the sugar business the longest and have made several visits to the area since. Of all the brothers, Robert Oxnard had the most contact with the Oxnard factory. He lived in San Francisco but visited twice a month while serving as vice president of the company. He even participated in a bowling league with the locals. Robert married but never had any children, and James Oxnard married Caroline Thornton, with whom he had to sons, James and Thomas. Henry T. Oxnard, through his legislative efforts and early involvement, was the most active of the brothers in establishing the factory in Oxnard. He lived in New York with his wife, Marie Picon, and two daughters, Adeline and Nadine. While the Oxnard family did not make Oxnard their permanent home, their efforts to establish a sugar beet industry in the United States gave the city a proud legacy. Pictured here are Robert Oxnard (seated) and, from left to right, James, Benjamin, and Henry Oxnard. (Courtesy Henry J. and Thornton Oxnard.)

Achille Levy

For 112 years, Bank of A. Levy was Ventura County's largest locally owned bank. It was started by Abraham "Achille" Levy, who was born in a small French village of Mommenheim, part of the region of Alsace-Lorraine. However, after the Prussians took over the area in 1871, Levy (along with more than 200,000 Alsatians) left. He landed in San Francisco, where his uncle Isidoer Weill put him to work at his store. Levy then went on to the new town of Hueneme, where he went to work for another relative, Moise Wolff. By 1875, 22-year-old Levy was the postmaster. The following year, he earned his citizenship and became a partner with Wolff in his mercantile store. Levy began venturing into the agricultural commodity business, selling grains, beans, barley, honey, fruit, and livestock to the growing farming population. By 1889, Levy ventured into banking. He cofounded the Bank of Hueneme and served as the first vice president. By 1900, he moved to the two-year-old town of Oxnard and began operating as Bank of A. Levy. The bank was initially located in a wooden building but, by 1901, had moved to a two-story brick block. A tremendous judge of character, Levy used to make "character loans." In his early years, he would ride horseback across the county and take notes of people's activities. If he determined that a person had a bad character, no matter how much collateral they could put up, he would not do business with them. After Achille passed away, son Joe Levy took over. Joe was in charge during the construction of the bank building on the corner of Fifth and A Streets. He had previously studied architecture at Stanford, but his father had discouraged any profession other than banking. Yet, his passion for building styles led him to design a new bank that incorporated Greek architectural features, including rounded arches, high windows, and Doric columns. Completed on May 23, 1927, the building remains one of Oxnard finest examples of its bygone eras. By 1940, Arthur Achille "Bud" Milligan (son of Achille's youngest daughter, Julia) became the third generation of Levy family members to join the bank. Bud's sons Michael and Marshall Milligan were the fourth (and last) generation of bankers. By the time Bank of A. Levy closed its doors in 1995, it included 17 branches throughout the county. The company was sold to First Interstate Bancorp for $86.5 million. Pictured are Joe Levy and Adolfo Camarillo. (Author's collection.)

Thomas Carroll

Thomas Carroll, a literal groundbreaker, was known for the quality and care he put into the things he built. He was responsible for building some of the earliest monuments and homes that have survived Oxnard's first century. Examples of his work include the Carnegie Art Museum, the Oxnard Pagoda, the interior of the Santa Clara Church, the St. Mary Magdalen Catholic Church in Camarillo, the Henry Levy home, and the L.G. Maulhardt ranch residence. Carroll was born in Nova Scotia, Newfoundland, in 1852 and came to Los Angeles in 1884. In 1900, he jumped at the opportunity to make his mark in the two-year-old town of Oxnard. He began work for contractors Parrish & Gourley and helped build the parochial schoolhouse St. Joseph's Institute (completed in 1901) and the original Bank of A. Levy block (completed in 1902) at the corner of B and Fifth Streets. His first independent job was in 1903, when he was in charge of the beautifully ornate interior of the Santa Clara Church. Over the years, he built the original St. John's Hospital, the McGrath Dairy, and homes for the families of Thomas McLoughlin, Raymond Peacock, Rudolph Beck, Sam Weill, J.J. Krouser, Jack Milligan, and Dr. William Livingston. Thomas's son Russell Carroll was also an early fixture in the area, working his way up to vice president during his 50-year career at Bank of A. Levy. Russell's daughter Sue married Art Thomas, a longtime bean thresher and son of blacksmith O.A. Thomas, and the couple eventually moved to Oregon. Thomas Carroll's daughter Ethel served nearly three decades as one of Oxnard's earliest librarians. Pictured are Thomas and Lena Carroll, around the 1890s. (Courtesy Patricia Laubacher.)

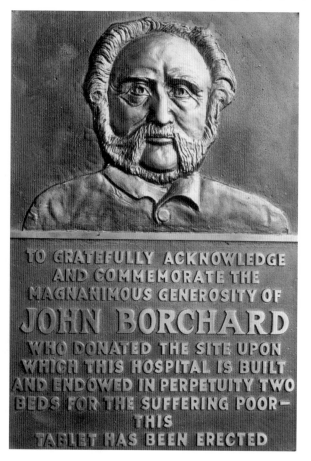

TO GRATEFULLY ACKNOWLEDGE AND COMMEMORATE THE MAGNANIMOUS GENEROSITY OF JOHN BORCHARD WHO DONATED THE SITE UPON WHICH THIS HOSPITAL IS BUILT AND ENDOWED IN PERPETUITY TWO BEDS FOR THE SUFFERING POOR— THIS TABLET HAS BEEN ERECTED

Johannes Borchard

Johannes (or "John") Borchard was among the first farmers to arrive on the Oxnard Plain in 1871. After many years of hard work and sacrifice, he was in the position to become one of the first major benefactors of the community. Borchard was born in Desingerode, Germany, in 1837, but grew up in the neighboring village of Werxhausen. He immigrated to America in 1871 with his wife, Elizabeth; two young sons; and little money. Tragically, after 3,000 miles of travel, both sons died before the family reached the West Coast. Johannes leased land from Juan Camarillo at 50¢ per acre. By December 1872, he and brothers Jacob and Gottfried Maulhardt purchased the 1,240 acres from Camarillo for $12,400, or $10 per acre. Soon, Johannes and Elisabeth started a new family with daughters Mary, Anna, and Theresa. Johannes planted barley and corn and raised sheep, cattle, and hogs. He owned over 8,000 acres throughout Ventura County, including land in the Conejo Valley, Ventura, and Oxnard. He also bought property in Orange County and Texas. A few years after settling his ranch near current-day Rose Avenue and Camino del Sol, he began his philanthropic endeavors, which included the purchase of the bell for the Santa Clara Church in New Jerusalem in 1877, as well as the donation of the parish's organ. In 1912, when a need arose for a new hospital on the Oxnard Plain, Borchard donated the land and made a gift of $20,000. Borchard also sponsored families from Germany, paying for their trips from Europe and giving them jobs when they arrived in Ventura County. The Friedrichs, the Diedrichs, and several other Borchard relatives all benefitted from his sponsorship and, in turn, became significant donors to the hospital. Johannes was as frugal as he was generous. When his daughter Theresa was preparing the plans for her marriage to Louis Maulhardt, she asked her father for a new pair of shoes. Knowing she already had a pair of Sunday shoes, he declined. She purchased a new pair against his wishes, and in protest to her defiance, he skipped her wedding. Fortunately, with time, there was forgiveness. Upon his passing in 1922, the *Oxnard Daily News* pointed out that one of his favorite hobbies was to "help people get on their feet." The plaque pictured here is located at St. John's Hospital. (Courtesy Rita Borchard Edsall.)

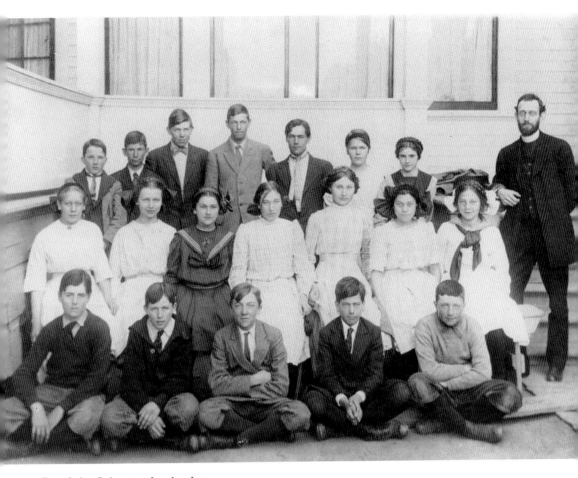

Rev. John Sylvester Laubacher

Rev. John Sylvester Laubacher came to Oxnard when the community was just beginning and took the lead in establishing a church, a school, and a hospital. He grew up in Malvern, Ohio, and began his studies at Mount Saint Mary's Seminary of the West in Cincinnati before traveling to Colorado Springs and, finally, Los Angeles, where he completed his theology studies while serving as professor of German at St. Vincent's College. He was ordained to the priesthood in June 1898 and, several months later, became an assistant to Rev. John Pujol at the Santa Clara Parish in New Jerusalem (present-day El Rio). He led the campaign to build the beautiful and ornate Santa Clara Church, completed in 1904, and was also instrumental in establishing the St. Joseph Institute (which became the Santa Clara schools) in 1901. Reverend Laubacher added a second Catholic Church, Our Lady of Guadalupe, to Oxnard in 1915. In 1910, Laubacher succeeded Pujol as pastor of Santa Clara Parish and turned his efforts toward establishing a Catholic hospital. He contacted the Sisters of Mercy and, through a series of letters and visits, brought them to Oxnard and introduced them to the community. The St. John's Hospital opened its door in a temporary building in 1912 and moved to a permanent structure two years later. After a series of name changes, the hospital has grown to become St. John's Hospitals, a Dignity Care member. Pictured are Rev. J.S. Laubacher and students from St. Joseph's Institute, around 1915. (Author's collection.)

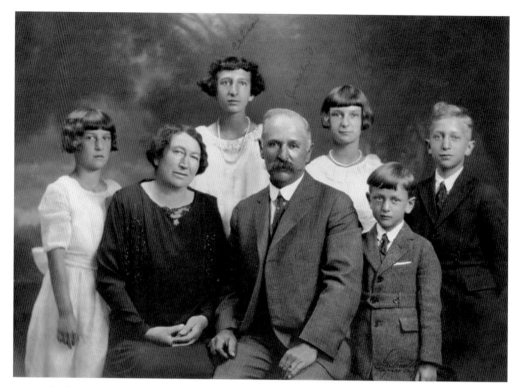

Joseph and Annie Friedrich

Few couples have given as much to the community as Franz "Joseph" Friedrich and his wife, Annie Borchard Friedrich. Joseph Friedrich was born in Desingerode, Germany, in 1871. He was 10 years old when he traveled to California with siblings Ignatz, Adolph, Mary, and Emily, and his parents, Franz and Magdalena Huch Friedrich. The family endured many hardships while reestablishing themselves in their new homeland. They settled in the Conejo area, where Franz, with the help of his sponsor Johannes Borchard, purchased a little over 1,000 acres. The inconsistent rainfall and lack of water almost sent the Friedrichs back to Germany. However, they relied on their faith to pull them through, and a saving rain allowed the family to make it through harvest season. With an eye on the more fertile Oxnard Plain, Franz picked up several properties within a few years, and things began to look up for the growing family. By 1891, Franz was able to purchase the 80-acre Goodyear Ranch in the Ocean View area. The next purchase was of 135 acres from William Zellar in 1903, located across the street from the Perkins house off Pleasant Valley Road—a portion of this land was donated to the Catholic Church and served as the home for Mary Star of the Sea Church and Catechism classes, and another portion became Brucker Field (after Frank and Mary Friedrich Brucker), used by the Senior League for the Port Hueneme Little League. The final property was 400 acres, purchased from Albert F. Maulhardt, located between Ventura and Saviers Roads and on either side of Channel Islands Boulevard. After Franz passed away in 1908, the properties were divided among the siblings. Joseph moved down and took over a portion of the Saviers Road ranch. He also took a bride, Annie Borchard, the daughter of Johannes Borchard, the man who sponsored the Friedrichs in 1882. Joseph and Annie's first child, Cecilia, was born in 1911. Elizabeth followed in 1913, and in 1914 son Joseph Ignatz Friedrichs became the first child born at the new St. John's Hospital through the innovated "twilight sleep" childbirth technique. By this time, the family had returned to the ranch of Annie's father, located off Rose Avenue and Colonia Road. Pictured is the Joseph and Annie Friedrich family. (Courtesy Gloria Friedrich Reed.)

Giving to the Community

By the 1950s, Joseph and Annie Friedrich began donating portions of their land to the Catholic Church. They gave 20 acres for the St. Anthony's and Santa Clara High Schools, and another six acres were donated for the site of Guadalupe School and Church. They also became the largest single donor toward the St. Johns Hospital expansion drive with a gift of $31,500. The next generation continued the contributions, with Joseph I. Friedrich and his wife, Gloria, becoming top donors for Santa Clara School and donating the lion's share for the Friedrich Pavilion. After Joseph passed away, Gloria carried on the tradition of giving by establishing the Joseph I. Friedrich Foundation. Because of her generous efforts, Gloria was named Philanthropist of the Year in 2006. Left, F. Joseph Friedrich is pictured turning the first shovel of dirt for the Santa Clara High School ground-breaking ceremony alongside Monsignor Jacobs and Father Kennedy. Pictured below are Gloria and Joseph Friedrich. (Both photographs courtesy Gloria Friedrich Reed.)

Martin V. Smith

Millionaire Martin V. "Bud" Smith was a real estate mogul and philanthropist with an empire that included more than 200 properties between Calabasas and Santa Maria. As a philanthropist, he gave away millions of dollars to several organizations. Smith was born October 18, 1916, in Sioux Falls, South Dakota, where his mother managed an apartment building. His father, a banker, suffered a heart attack and died soon after the stock market crash of 1929. The family moved to Beverly Hills, and Smith dropped out of high school and began servicing a series of vending machines from Los Angeles to Santa Barbara. In 1941, he traded a collection of jukeboxes for a failing hamburger drive-in on Oxnard Boulevard. The Oxnard Motor Hotel and the Colonial Drive-In Café were built by Edwin Carty, who leased the drive-in to Art Ellison. When Ellison

offered to swap businesses, Smith jumped at the opportunity. He struggled at first, but landlord Carty gave him a break. In a 1995 interview, Smith explained, "If it wasn't for Ed Carty, I wouldn't have made it. He carried me when I couldn't make the rent." Carty even allowed Smith to pick lettuce or tomatoes as needed from the adjacent farmland. Soon after taking over the stand, Smith was shipped out to the South Pacific with the Army Air Force. The restaurant, left in the care of his wife, sister, and mother, was thriving when he returned. He soon bought 40 acres of Henry Borchard's land near the freeway and the Santa Clara River. It seemed an odd purchase to some because the land was prone to flooding, but the problem was solved with the construction of a levee. The property became the site of the Wagon Wheel Junction, the site of a motel and a collection of offices, shops, and restaurants. The Wagon Wheel Motel, completed in 1947, quickly became a popular stop for travelers between Los Angeles and Santa Barbara. The Trade Winds restaurant—built in 1964 and designed by Fred Moniger of 20th Century Fox and decorator Ione Keenan—featured a lagoon with a Chinese junk and was decorated throughout with items collected on Bud's world travels. Don Ho and the Beach Boys performed there, and guests would be brought in by rickshaw from the Wagon Wheel Motel. Bud went on to build the Channel Islands Peninsula, including the Casa Sirena Resort, Villa Sirena Apartments, and the Lobster Trap Restaurant. Smith also built the Financial Plaza, which included the 20-story tower, constructed in 1985, that remains the tallest building in the county. In 1996, Smith sold the majority of his holdings, including the Financial Plaza complex, eight hotels, more than 1,000 apartment units, and several restaurants. The $175-million deal was the largest property sale in county history at that time. (Courtesy Victoria Pozzi.)

Martha K. Smith

Martha Katherine Bergstrom, a daughter of Swedish immigrants, was born in Lead, South Dakota. She and her widowed mother came to California, where Martha attended Fairfax High School and then Los Angeles City College. She took dance lessons from Eduardo Cansino, father of Rita Hayworth. Martha was hired by Busby Berkeley and performed in dozens of musicals for Paramount Pictures, MGM Studios, RKO Studios, and Hal Roach Studios. She also worked as the stand-in for Claudette Colbert. Also an accomplished skater, she toured with the Westwood Ice Follies. She was selected for the Hollywood Review ice show after being spotted by Olympic ice-skating champion Sonja Henie. Martha met her future husband, Martin V. Smith, on a blind date in 1942. Within a year, she abandoned her film career and dedicated herself to her new life in Oxnard. She was instrumental in helping her husband establish his café in town, and when Martin was away serving a stint in the Army Air Corps during World War II, Martha, her mother, and her sister-in-law took over. When Martin returned, business was booming. The café was renamed the Colonial House, and over the years, many Hollywood stars have frequented it, including Clark Gable, Marilyn Monroe and Joe DiMaggio, Bing Crosby, John Wayne, and David Jansen. Martha and her husband created the Martin V. and Martha K. Smith Foundation, through which they financed the construction of the Boys and Girls Club of Oxnard and donated $8 million for the construction the Martin V. Smith School of Business and Economics at the California State University, Channel Islands. (Author's collection.)

Mike Vujovich

Michael Gustav Vujovich's is a classic rags-to-riches story. Born in 1888 in Bilak, Austria, at age 18 he snuck onto a ship that was headed toward Italy and then talked his way onto a transfer ship bound for New York. He eventually made it to Ventura County, where he started at the Schiapa Pietra ranch in El Rio under the direction of George Power. He then went to work for Joe Donlon in El Rio, followed by farming stints with Tom McLoughlin, Manuel Siva, Robert Beardsley, James Leonard, Bernard Smith, Adolfo Camarillo, and Otis Snow. In 1919, he rented 252 acres from Mary Borchard Ayala to grow beets and alfalfa. He struggled until the harvest of 1926, when he hit pay dirt with a $33,000 take-home income. He next leased 400 acres near Round Mountain from the American Crystal Sugar Factory and, by 1932, he was able to purchase his own property. In addition to farming, Mike joined the boards of the Drainage district and Camarillo State Hospital and spent 16 years as a trustee for the Oxnard School District, where he gave out a $50 scholarship to two students. (Courtesy William Howard Maulhardt.)

The Hiji Brothers Give Back

The Hiji family's roots in Oxnard can be traced back more than half a century. Tsugio, Frank, and Robert Hiji started farming a mere 10 acres with their father, Saheiji, in 1950. They later expanded their farming operations over 2,500 acres in various parts of California and Mexico. They planted a variety of crops over their farming history, including several introduced by the Hiji brothers. They began with celery and soon added leaf lettuce, tomatoes, green beans, cabbage, and strawberries. The brothers did not limit their investments to row crops. They opened a nursery, Seaview Growers, as well as Cal Coast Machinery, which offers John Deere farm machinery in Oxnard, Paso Robles, and Santa Maria. In 1969, they created Cal-Cel Marketing to handle the distribution and marketing for their farm operations. More recently, the family has ventured into commercial real estate development. From their first years in Oxnard, the Hiji family has pledged to help the hospital. Tsugio Hiji, the eldest of the three brothers, is a Charter Humanitarian for his early donation. The brothers' generosity extends beyond the hospital. They have also given generously to the Japanese American Museum in Los Angeles, the Camarillo YMCA (which named the Hiji Center in their honor), and the Camarillo Library. More recently, they donated to St. John's Hospital for the addition of the Hiji Family Healing Garden, a two-acre, three-tiered garden area of manicured paths, lawns, fountains, and other water features, with a 55-foot sequoia to serve as a Christmas tree for future generations. The idea for the garden came from longtime hospital sponsor Joe Burdullis. Burdullis knew the hospital grounds well from extensive visits over the years. "I'd spent several months visiting friends in serious conditions here and at St. John's Pleasant Valley. I saw a need for a more comfortable setting . . . and the significance of the idea of the culture of healing." It was Burdullis who helped convince the Hiji family to become major donors for the project. While the garden will be visible to half of the 230 patients from their room, the entire community will benefit from this tranquil spot. St. John's CEO Laurie Eberst concludes, "This will be a place where real healing happens . . . Water is such a healing thing." (Courtesy Hiji brothers.)

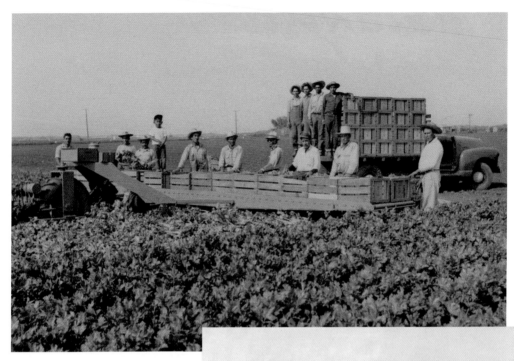

Dullam Nursery

As the agriculture in Ventura County has changed, so has the farming. The Dullam family changed with the times and has helped lead the way to making strawberries the area's biggest crop. John Ernest Dullam immigrated to California from England in 1901 to farm with his uncle Richard Watts. He leased pastureland from the Hancock family near the La Brea Tar Pits. With the city closing in on him, he bought a farm out in the country near Sepulveda and National Boulevards in 1919. Dullam grew spinach for the Sunny Sally Company, and in 1941 Dullam Nursery was formed. After graduating from the University of California, Los Angeles (UCLA), son John F. Dullam worked for MGM Studios as a studio sound mixer. By 1943, however, he was drawn back to the soil to work with his father. (Courtesy John and Linda Dullam.)

Dullams Farm Oxnard

After World War II, the Dullams sold their land for a housing development. They moved to Oxnard in 1951 and leased 60 acres off Teal Club Road. Frank Dullam, John F. Dullam's brother, split off from the family and bought 160 acres near Camarillo, as well as some property in Saticoy. In 1958, John F. Dullam helped organize the Oxnard Frozen Food Cooperative. He, Frank and John Vujovich, Milton Diedrich, John Laubacher, and A.A. Milligan from Bank of A. Levy purchased Ventura Farms—which had been formed in 1947 to handle green lima beans—for $3.5 million. The cooperative was set up to guarantee an outlet to handle crops year-round. Dullam worked there until 1985, and son John Thomas Dullam took over. His sister Toni Hooper and his wife, Linda, have both worked in the office and been active in helping John grow the business. Even his nephew Paul Hooper can be seen selling strawberries for his uncle at the Farmers Market or at the Strawberry Festival. The Dullam Nursery is located on a few acres near the Oxnard Airport. The greenhouses are used to grow young vegetable plants for other farmers. For the strawberries, Dullam leases about 300 acres in Oxnard off Etting Road. He has seen the growth of the strawberry industry explode since 1975, when there were only 2,100 acres in production. The industry in Ventura County reached $525 million in 2009, and by 2011 there were 11,800 acres planted. This would not be possible without the improvement in production. Working with the University of California, Dullam was able to come up with an improved strawberry. According to him, the priorities when breeding strawberries are flavor, appearance, color, size, disease resistance, and the ability to ship. "To make all these factors come together," he says, "is nearly a miracle." John has called strawberries "the happy crop" for their ability to "make people smile." His efforts to improve the industry have certainly put a smile on a lot of faces, and Oxnard, initiated with the sugar beet, has continued to thrive with the sweet strawberry. (Courtesy John and Linda Dullam.)

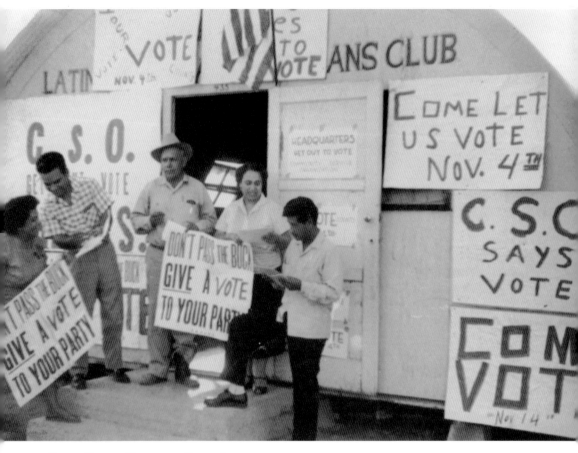

Cesar Chavez Comes to Oxnard

Though the time he spent in Oxnard was brief, Cesar Chavez's impact in the community has been limitless. In 1938, when he was 11 years old, Chavez briefly lived in Oxnard. However, it was his return in October 1958 and his use of nonviolence to conquer the violence of injustice that had a lasting effect that carries on to this day. Chavez returned to Oxnard as part of the Community Service Organization (CSO), a group that helped with immigration issues, tax problems, and community organization. The United Packinghouse Workers of America provided $20,000 of funding for the CSO to help solidify and expand its union base in the region. The *Oxnard Courier* quoted Chavez in October 7, 1958, explaining that the purpose of the organization was to help Spanish-speaking residents "become more oriented into the mainstream of community life." One objective was to register voters, which was accomplished by going door to door. The other goal of the CSO was to offer citizen classes, which were set up at Juanita School (late renamed Cesar Chavez School). Within the first year, voter registration in the Colonia area rose from 400 to over 1,000. Here, Cesar Chavez is pictured at his campaign office on Hayes Street. (Courtesy Wayne State University.)

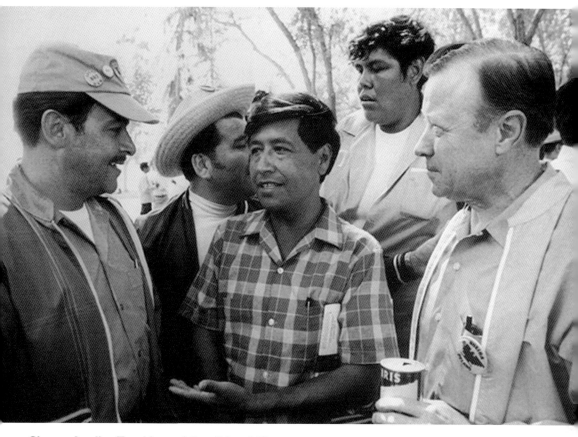

Chavez Applies Teachings of Gandhi and King

Cesar Chavez read about and was inspired by the lives of Mohandas K. Gandhi, Martin Luther King Jr., as well St. Francis of Assisi, all of whom taught a philosophy of nonviolence and honoring the inherent worth of every human being. Chavez realized violence only begets violence and applied this principle as he sought change in Oxnard. Chavez was instrumental in setting up several silent protests that spoke loudly to the growers. On April 15, 1959, workers at the Bob Jones Ranch participated in a sit-down strike at 10:00 a.m. They were protesting the growers' attempt to pay the workers per "piece wages" instead of the going rate of 85¢ an hour. After two hours of negotiations between the CSO and the director of the State Department in Sacramento, the dispute was resolved, and the workers returned to work at the prevailing wage. However, Chavez began to realize that there was a different set of hiring rules for domestic workers and those participating in the federally funded Bracero Program. He felt that the participants were being exploited and that the domestic labor force was being undermined. Eventually, the CSO was able to expose the collusion of federal and state agencies in not carrying out the protections and regulations of Public Law 78, which governed the Bracero Program. Chavez and 60 or so followers marched from Colonia and toward Plaza Park. Chavez said, "That's when we discovered the power of the march. We started with a couple of hundred people in La Colonia and by the time we got through we must have had 10,000 people." Realizing that the CSO needed to take up the cause of the farm workers to unionize, he joined forces with Dolores Huerta and Gilbert Padilla to start the National Farm Workers Association (NFWA). By applying the philosophies of Mahatma Gandhi and Martin Luther King, along with the success of his Oxnard experience, Cesar Chavez was ready to take on the rest of the state. He is pictured here meeting political activist Hank Lacayo Jr. in 1965. (Author's collection.)

Armando J. Lopez

Oxnard native Armando Lopez has risen from humble beginnings to become one of the town's most influential developers, as well as a leading promoter of the arts. His parents, Antonio and Maria Lopez, arrived in Ventura County in the 1920s. Antonio picked lemons for Limco del Mar in Santa Paula. By the 1940s, the family relocated to Oxnard, where Antonio worked at the Oxnard sugar factory. The Lopezes also operated a deli off Meta Street, where they served fresh-baked goods. Armando, a fast learner, graduated from Driffill Elementary, Haydock Intermediate, Oxnard High, and then went on to California State University, Northridge. He allowed his firsthand knowledge of the streets and alleys of downtown Oxnard to guide him in getting a degree in social services. Between 1964 and 1984, Armando taught at Moorpark and Oxnard Colleges and was also involved in job training and social and human services. He was always involved in politics and dabbled in real estate. Melding these skills, he began consulting and, eventually, became a partner in a real estate brokerage. Armando held the top leadership roles for land development companies at Bondy Corporation, Hopkins Industries, and La Playa Cable. He also started the Armando Lopez Company and worked as a consultant to US companies interested in doing business in Mexico. Armando Lopez's services expanded with the growth of the city. He became a partner in Plaza Development Partners LLP, which built the multiscreen theater and restaurant complex in downtown Oxnard. In 2005, he was voted Oxnard's Distinguished Citizen. Other major developments in which he had a leadership role were the Victoria Estates (a 330-acre, guard-gated community with 446 upscale homes, a church, an elementary school, an office building, and a municipally owned golf course) and River Park (a $750-million, 700-acre mixed residential/commercial project at the junction of the Ventura Freeway and Pacific Coast Highway). Armando cites the River Park project as the one he is most proud of, because "it took a lot of effort, a lot [of] cooperation, and a little right place at the right time."

Meanwhile, his efforts in the arts were also expanding. He became the president of the Downtown Center for the Arts, and in 2006, he was named Oxnard Arts Businessman of the Year. (Courtesy Armando Lopez.)

CHAPTER THREE

Civic Leaders and Public Servants

This chapter of civic leaders and public servants includes a variety of contributors to the betterment of Oxnard. Oxnard prides itself on cultural diversity, and these legendary Oxnardians were on the forefront of the charge for change. They range from Richard Haydock, who championed first-rate schools with room for outdoor activities, to Daisy Tatum, who treated each student like they were her own; from William Soo Hoo, who became the first mayor in the United States of Asian descent, to Jane Tolmach, who took her conversation concerns all the way to a seat on the Oxnard City Council; and from Bedford Packard, who strove to establish a boxing outlet for the youth in the area, to Robert Valles, who was honored with his name atop the Performing Arts Center at Pacifica High School. These individuals worked to bring the best to the most.

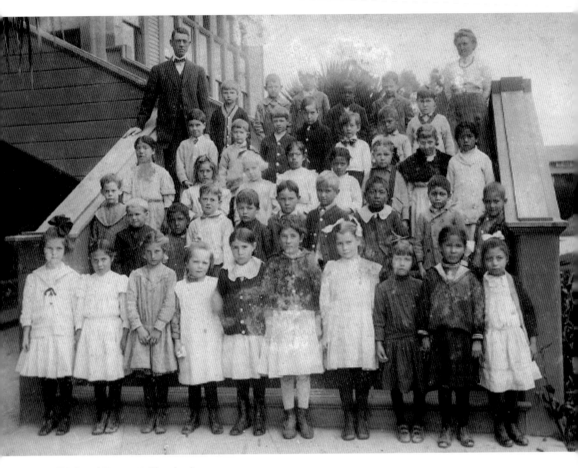

Richard Barrett Haydock

Richard Haydock was born in Kentucky in 1867 and came to Ventura by 1876. He enrolled in the Los Angeles Normal School, graduating in December 1885. In the fall of 1886, he began teaching school in Hueneme. After only one year, Haydock was promoted to principal, and he taught and ran the school for the next 12 years. In 1888, he was elected to the county board of education, on which he served for 45 years. In 1901, he was elected superintendent of the Oxnard schools. During his tenure, Oxnard had some of the grandest-looking schools, including Oxnard Grammar School, Haydock Grammar School, Wilson Grammar School, and Oxnard High School. In June 1903, Richard Haydock was voted the first mayor of Oxnard. He is pictured here with students at Oxnard Grammar School, around 1901. (Author's collection.)

Superintendent of Schools

Haydock became superintendent of schools in Ventura in 1906, but in 1911 he returned to Oxnard, where he served as superintendent for the next 28 years. In 1916, when the district decided to add a second grammar school off C Street, they named it Richard B. Haydock Grammar School. (Years later, when the school was razed and a new junior high school was built off Hill Street, the name was reassigned to the Intermediate School.) Haydock was also instrumental in applying for the grant money ($10,000 from the Carnegie Library Board) to build Oxnard's first library in 1906. He came up with a sketch for the type of building he thought would be timeless and brought in nationally recognized architect Franklin P. Burnham for the project. Above is a postcard of the Oxnard Grammar School, and pictured below is the Wilson School. (Author's collection.)

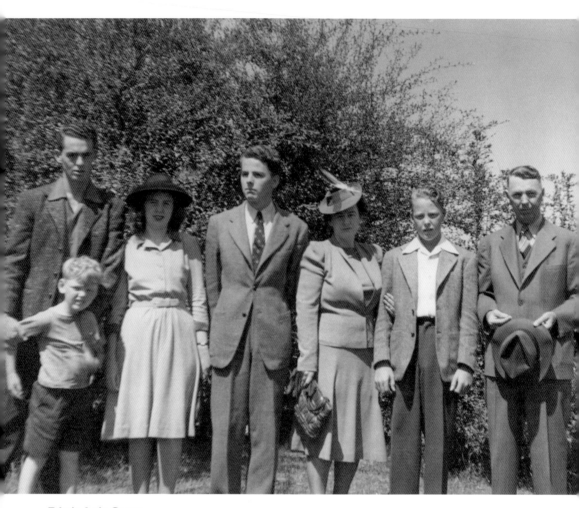

Edwin Luis Carty

Ed Carty wore many hats during his tenure in Oxnard. He was a farmer, an insurance agent, a real estate developer, mayor, supervisor, and a world-class hunter. He was born in Santa Barbara on December 4, 1897, to Cornelius and Emma Maulhardt Carty. His mother passed away when he was 11 years old, and he moved to Ventura to live with his grandmother Doretta Maulhardt. He attended Ventura High School, where he was involved in many activities and served as senior class president in 1916. His senior horoscope predicted he would "invent a pod-less bean." His grandmother gave him 25 acres of her north Oxnard ranch. On December 23, 1918, he married his high school sweetheart, Doris McDonnell, at the Ventura Mission in a ceremony officiated by Rev. Patrick Grogan. For the next two years, Ed farmed his grandmother's 100 acres between Magnolia and (present-day) Roderick Streets. His first year, he earned over $20,000 from growing lima beans. The following year, though, reality hit when he brought in just $4,000. He next tried carrots, the first to be sold outside the state. After surviving a life-threatening illness in 1926, Edwin turned to selling insurance and dabbled in real estate. Beginning in 1936, he began developing his ranch. He chose family names for the streets, including Carty; Doris (for his wife); and Robert, Roderick, and Douglas (for his children). He also built the Oxnard Motor Hotel and the Colonial Drive-In Café, which he rented to Martin V. Smith. By 1938, Ed was offering five-bedroom homes for $25 down and $25 a month for 25 years. His own family home still stands on Roderick Avenue. The Carty family is pictured here around the 1940s. (Author's collection.)

Mayor Carty

By 1939, Ed won an appointment to the California Fish and Game Commission. He took numerous trips around the world and hunted for a variety of species, many of which became part of his extensive trophy and game room. In 1942, he became mayor. He helped create a city manager system as well as a master plan for the city. He also had a hand in the creation of the small-craft harbor and the Oxnard Airport. He remained in office until 1950, and in 1952 he was elected as Ventura County superior (an office he held until 1965). He was on the board that approved the creation of the Channel Islands Harbor and the Emma Wood Memorial State Beach. He is pictured above tipping his hat during a ride with the Rancheros Vistadores, and to the left with his wife, Doris, in their den in 1975. (Both photographs, author's collection.)

Bill Soo Hoo

William "Bill" Du Chun Soo Hoo, born in Oxnard in 1924, was the first person of Chinese heritage in the United States to be elected mayor. He was a man with strong principles, a good work ethic, the heart of a patriot, and the courage of his convictions. He was the son of Soo Hoo Yee Tom and Soo Hoo Jung Hall (also known as "Mama Soo Hoo"). Yee Tom had worked in China as a junk captain. The family moved to Oxnard in 1920 and opened a general store called Wing Chen Lung Company, located on China Alley. They also opened a restaurant in an area referred to as "Old Duck Pond," also in China Alley. The restaurant, later called the Oriental Inn, was torn down in 1948, and a new restaurant, Mamma Soo Hoo's Orient, was built on Oxnard Boulevard in 1949.

Bill entered the Army in 1943 and earned two battle stars while serving in Europe. When he returned to Oxnard in 1946, three new military bases had been built, and the town had grown from 8,000 to 13,000 residents. Bill wanted to build a house on a lot on Deodar Avenue in Oxnard, but he was refused due to a "Caucasians only" clause. After serving his country with honor, Bill felt called to get involved in bringing some changes to his hometown. He began by serving on the grand jury in 1956. By 1962, he was elected to the city council, and he made headlines throughout the world in 1966 when he became mayor. As mayor, he was the most proud of the development that took place in the city, including the building of the inland harbor, additional fire departments, and a cultural arts center. He loved the city of Oxnard and worked hard to make significant contributions. The Soo Hoo family is pictured here. (Courtesy Carrie Pell Dominguez.)

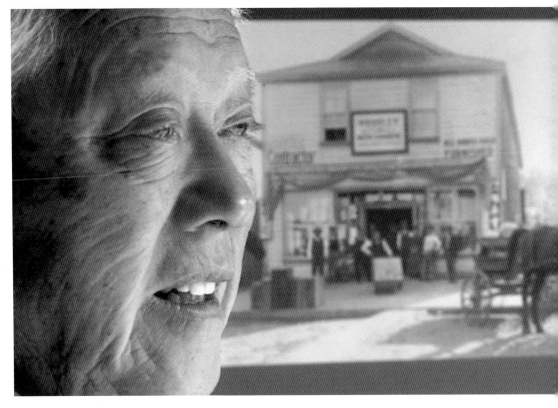

Nao Takasugi

Few people have garnered as much respect and admiration as Nao Takasugi. Jesse Ramirez, a colleague from the Harbor District, noted that he was "well loved by everyone in the community regardless of race." Many have stated that he never said a negative thing about anyone—quite a feat for man who spent over three decades of his life as a public servant. Takasugi served on the planning commission, city council, Oxnard Harbor District board, and as mayor assemblyman. He was born on April 5, 1922, at St. John's Hospital. His family owned Asahi Market, which they opened in 1907, and he began working at the market at an early age. He was valedictorian of Oxnard High's class of 1939 and was continuing his education at UCLA when his life was put on hold with the order to relocate to an internment camp at Gila, Arizona. At the camp, he earned $16 a month as a Spanish and business tutor. After several months at the camp, a Quaker organization offered Takasugi a chance to complete his degree. He received a bachelor's degree from Temple University in Philadelphia, and a master's degree in business administration from Wharton School at the University of Pennsylvania in 1946. Takasugi returned to Oxnard to help run his family's business. "Being the only son, I had no choice," he told Tom Brokaw in an interview for Brokaw's 1998 book *The Greatest Generation*. It was only after a frustrating attempt in his dealings with the city to add a new sign to his store that he decided to become part of the decision making as a public servant. He won a seat on the Oxnard City Council in 1976, and in 1982 he was elected mayor, remaining in office for 10 years. In 1992, Takasugi was elected to the California State Assembly as a moderate with the Republican Party. Due to term limits, he had to step aside after serving three terms. In 2000, he began an eight-year run on the board of the Oxnard Harbor District. Nao Takasugi shared a lasting insight that was also included in the Brokaw book. In reference to injustices that were placed upon his family during the war years in the 1940s, Takasugi offered, "I find that I am compelled to remember the best—not the worst—of that time. To focus not on the grave deprivation of rights which beset all of us, but rather on the countless shining moments of virtue that emerged from the shadows of that dark hour." (Author's collection.)

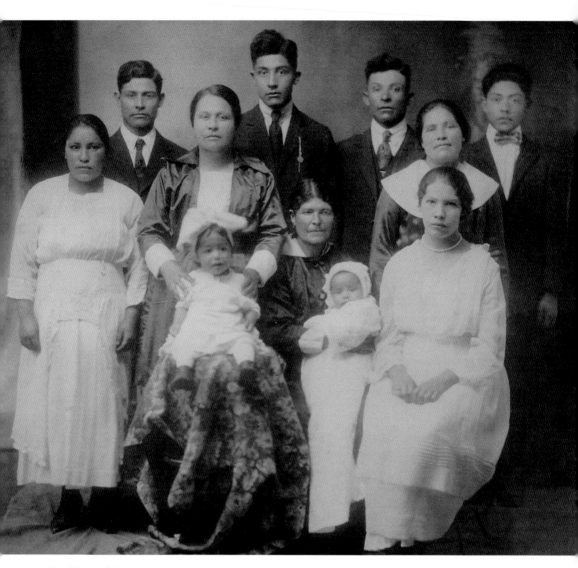

Dr. Manuel Lopez

Manny Lopez was born in 1927 in Oxnard to Manuel C. and Isabel Martinez Lopez. His father came to California in 1916 and worked at Charles Donlon's lemon ranch near the current Financial Plaza. Along with siblings Joe, Gilbert, and Ruth, Manny went to school in El Rio. However, by 1940, he was sent to the hospital to be treated for tuberculosis. For the next 13 years, Lopez split his time between the hospital and his bed at home. It was during these long, lonesome hours that he turned to the radio for companionship. He listened intently to the Roosevelt campaign on the radio, an experience that remained with him. After the Donlon ranch sold in 1942, the Lopez family settled in a house built by Manny's father at 125 Roosevelt Street. By 1953, Manny Lopez was ready to complete his education. He attended Ventura Community College, the University of California (Berkeley), and the University of California (Berkeley) School of Optometry. By 1962, he was Dr. Lopez, an optometrist operating at the corner of A and Second Streets. The Lopez family is pictured around 1920. From left to right are Manny's parents, Isabel and Manuel; Maria Lopez Aguilar (holding child); Antonio Lopez; grandmother Cayetana Lopez (with child); Jesus Lopez; Maria Lopez Lara; Ricarda Salse Lopez (front); and Rafael Lopez. (Courtesy Dr. Manny Lopez.)

Dr. Manny Lopez, the Rise to Mayor

Lopez married Irma Luna, and together they raised daughters Marisa and Tiffany.

In 1964, Dr. Lopez was instrumental in establishing the sister city relationship between Oxnard and Ocotlán, Jalisco, Mexico. He began his government service in 1965 as a member of the Oxnard Community Relations Commission and was next appointed to the Oxnard Planning Commission, followed by a stint with the Oxnard Housing Authority, and then the Oxnard Redevelopment Agency. He was elected to the Oxnard City Council in 1978, and from 1992 to 2004 he served as Oxnard's mayor. Dr. Lopez's proudest achievement is the Veterans Memorial at Plaza Park, which was inspired by the Vietnam Veterans "Wall" Memorial in Washington, DC. (Courtesy Dr. Manny Lopez.)

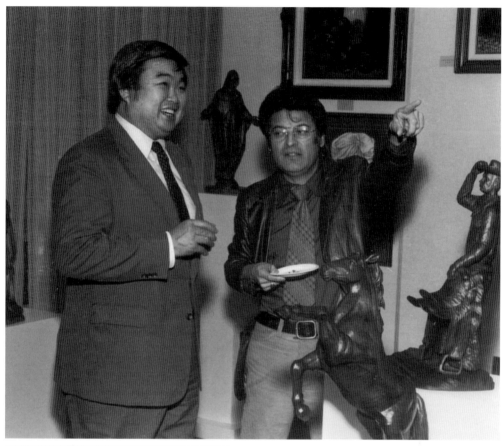

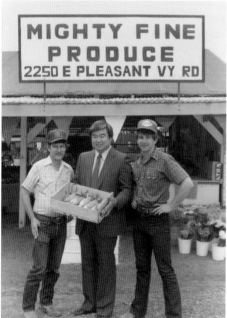

Tsujio Kato

Tsujio Kato was born in Oxnard in 1938. As a boy, he was interned with his family at Gila River, Arizona. He graduated from Oxnard High School in 1956, where he served as student body president and captain of the football team. He then earned a degree from Fairleigh Dickinson University's School of Dentistry in 1965 and immediately opened his practice in Oxnard. In 1972, Tsujio won a seat on the city council, and by 1976 he was elected mayor. In 1984, he helped establish the California Strawberry Festival, which generates more than $500,000 annually for a variety of local nonprofit groups. Kato's legacy was cemented when the main stage used at Strawberry Festival at College Park was designated the Tsugio Kato Amphitheater. Kato is pictured above (left) with Dr. Lopez. In the photograph on the left are Frank Naumann (left), Kato (center), and Mark Golden. (Above, courtesy Dr. Manny Lopez; left, courtesy Frank Naumann.)

Jack O'Connell

Jack O'Connell has always kept education on the forefront of his priorities. He graduated from Oxnard High School (where he lettered in baseball and basketball) in 1969 and returned to teach at his alma mater from 1975 to 1980 before setting out on the road to government. He was born in New York, where his father was a Brooklyn Dodger fan. When the Dodgers moved west in 1958, the O'Connell family followed. As a student, Jack invited state senator Omer Rains to speak to his class and, soon after, took a position with Rains as an administrative assistant. In 1981, Jack began serving his first political post on the Santa Barbara School Board. He next won an election to represent the 45th District. In 1994, Jack took his next step up the political ladder, entering the state senate. He authored SB 623, which approved the transfer of the former hospital to the California State University system. By 2002, Jack O'Connell made the next logical step in his political career when he won the position of California state superintendent of schools. (Courtesy Tiffany Israel.)

Madeline Miedema

Madeline Miedema was an educator, author, civic crusader, and Oxnard's original historian. She came to Oxnard in 1918 with her father, Rev. William Miedema, who served as minister of the First Presbyterian Church in Oxnard. She attended Haydock Elementary School and Oxnard High School and, in 1949, began teaching English and history at Oxnard High. She eventually became curriculum director, a role she filled until 1975. After retirement, Madeline served as director of the Ventura County Museum of History and Art. For the next 30 years, she investigated Oxnard's early days. She is quoted saying, "I'm always impressed with the great optimism of the early residents of Oxnard," adding, "They thought it was the greatest little town on the West Coast." She also contributed several articles to the quarterly *Ventura County History Journal*, including "Oxnard's Golden Decade" and "A Giant Step Forward: A History of the Oxnard Public Library." Additionally, Miedema was a member of the Oxnard Library's board of trustees and a member of the Ventura County Cultural Heritage Board. She helped establish buildings and locations as historical landmarks, including the Oxnard Pagoda and the Carnegie building. (Drawing by Jullianne De La Cruz.)

Robert J. Frank

Robert John "Bob" Frank was much more than just a science teacher. He headed several clubs, including photography, astronomy, rockets, journalism, and coaching while teaching at Fremont Intermediate School. He was known for his fairness and for treating people the same whether their parents were doctors or field workers. Born in Chicago, Illinois, Frank graduated high school in 1941 and served five years in the Army. He met his future wife, Loretta Crandall, in Baltimore. Bob enrolled at Arizona State College and then came to Oxnard to begin teaching in 1953. To supplement his income, he also worked for the City of Oxnard. Bob retired in 1983. In 1988, the voters of Oxnard passed a $40-million bond to build several new schools, and on July 12, 1991, ground was broken for the Robert J. Frank Intermediate School. "He was the most outstanding teacher anyone in our community ever experienced," superintendent Norman R. Brekke said. (Courtesy Patrick Frank.)

Merlin's at it again!

R. Frank A. Schopfer
M. Jones

What is Ecology?

Alchemists

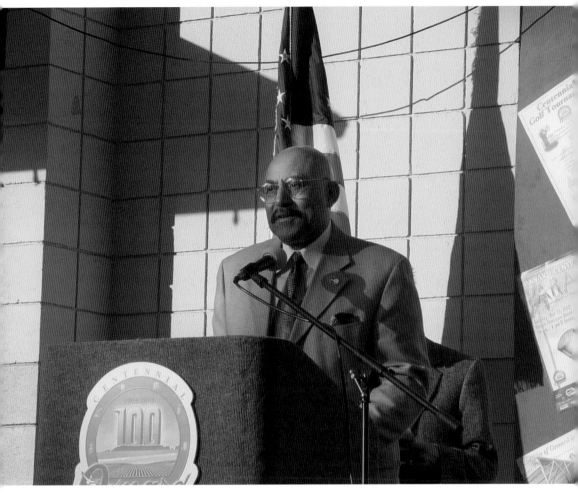

Bedford Pinkard

Bedford Pinkard has been a lifelong supporter of youth sports in Oxnard, and for his many efforts the city honored him with the naming of the Bedford Pinkard Skate Park. Pinkard was born in Jacksonville, Texas, on October 9, 1931, to Dee and Adela Pinkard. The family moved to Oxnard in 1940, and Bedford graduated from Oxnard High School (where he was on the football, basketball, and track teams) in 1950. By 1961, Bedford began working for the Parks and Recreation Department, rising to the position of recreation supervisor. He participated in many civic and nonprofit organizations, including the Ventura County Grand Jury, the Oxnard School District Personnel Commission, and the Oxnard Union High School District Board of Trustees (1973–1992). He was also founder of the Multicultural Festival, project coordinator to reduce youth crime and gang-related violence in Oxnard, and founder of the world renowned La Colonia Youth Boxing Program. He was elected to the city council in 1992 and served for 12 years. His wife, Irene, became the next Pinkard to take office as a council member when she was elected in 2008. (Author's collection.)

Robert Q. Valles

Robert Q. Valles, a 1954 graduate of Oxnard High School, holds an associate's degree from Ventura College, a bachelor's degree from UCLA, and a degree in business administration from the University of LaVerne. He worked 30 years as director of the employment and equal opportunity division at the US Naval Construction Battalion Center in Port Hueneme. In 1994, he won a seat on the board of the Oxnard Union High School District. "If industry and business expect a quality student, then they're going to have to get involved with the schools," he once said. Once elected to the board, Valles campaigned for a state-of-the-art high school, which was achieved when Pacifica High School opened its doors in 2001. The 50-acre site includes nine major buildings; the largest high school gymnasium in the county; and the Robert Q. Valles Performing Arts Center, named for this longtime proponent of student success. Pictured are Robert's parents, Quinto and Gaia, with their daughter Rose. (Above, courtesy Bob Valles; left, courtesy Erica Gonzalez.)

John C. Zaragoza

John Zaragoza, a third-generation Oxnard native, has dedicated his adult life to the service of the community, participating with dozens of civic organizations. Zaragoza was inducted into the Oxnard High School Hall of Fame where he shared his favorite quote from Winston Churchill: "Continuous effort, not strength or intelligence, is the key to unlocking our potential." Zaragoza worked for the City of Oxnard for over 30 years, last 15 of which he spent as the head of the solid waste division. After retiring from this position, Zaragoza was elected to the city council in 1996. In 2008, he became the Ventura County supervisor of District 5. Zaragoza is pictured to the left, around 1960. Below, he is seen with the author (center) and Bill Rattazzi (right). (Left, courtesy John Zaragoza; below, courtesy John Laing Homes.)

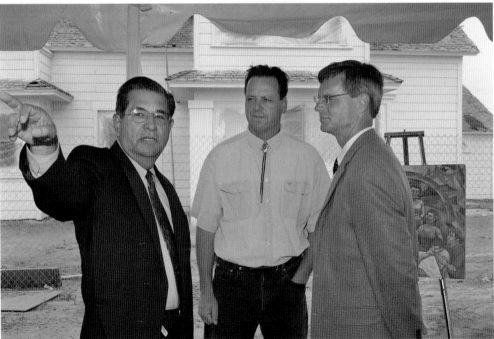

Sylvia Munoz Schnopp
Civic duty runs deep in the family of Sylvia Andrea Munoz Schnopp. Sylvia graduated from Santa Clara High School in Oxnard and went on to become the mayor of Port Hueneme as well an author of an exhaustive study on the Cristero Revolution, the 20th-century religious civil war of Mexico. The greatest influences in her life have been her parents, Jose and Herminia Basulto Muñoz, who emigrated as young adults from Mexico to the United States. Her mother and aunts originated from Ocotlán, Jalisco, and came to live with their grandparents, who had settled in Oxnard to work at the Sugar Beet factory in the 1900s. Her father arrived from Arandas, Jalisco, and went on to become chef for a local labor camp. Sylvia is an adjunct college business professor at Oxnard College and has been a licensed minister since 2006. She was first elected to the Port Hueneme City Council in 2008 and served as mayor from 2010 to 2011. Currently, she is currently pursuing publication for her first work of historical fiction, which is based on her family's true stories of Mexico's Cristero Revolution in the 1920s. (Courtesy Sylvia Schnopp.)

Daisy Tatum

Daisy Tatum holds the philosophy that "anything is possible, if you want it bad enough and you're willing to work for it!" She began her teaching career in Oxnard in 1969 at Channel Islands High School and, five years later, was promoted to assistant principal at Hueneme High School. She was later appointed interim principal at Frontier High. In 1994, she became the first African American principal in Ventura County when she was assigned to Oxnard High. Attendance and test scores increased, while the number of fights decreased. She arrived at school at 5:00 a.m. and did not leave until as late as 10:00 p.m. Each day, she made it a point to say hello to a student she did not know. In March 2001, Tatum was named chair of the California Strawberry Festival. Having been a board member since 1986 and a volunteer at the first festival in 1984, she was well acquainted with the organization. Her legacy is that she has lived by example and proved that, with enough hard work, anything is possible. She is pictured, right, while serving as executive chair of the Strawberry Festival Committee. (Courtesy Frank Naumann.)

CHAPTER FOUR

Interesting Characters

Oxnard is full of interesting characters. There are mischievous spirits like Erle Stanley Gardner, who cut his legal teeth in the city of Oxnard. There are those who are well rounded and ahead of their time, such as Lydia Pfeiler, who was on the forefront of the early development of the arts in Oxnard. Morey Navarro is known for having a big heart, and Catherine Mervyn is the queen of persistence. Then there are the characters: the people who play people. Brandon Cruz played Eddie on television series *The Courtship of Eddie's Father*. Lucy Hicks lived as a woman in Oxnard for 30 years until it was discovered that she had been born Tobias Hicks, a male.

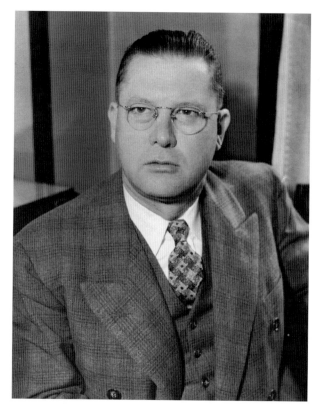

Erle Stanley Gardner, the Oxnard Years

Most people know that Erle Stanley Gardner is the author of the Perry Mason mysteries, 82 in all. Some may know that he spent several years in Ventura working with respected lawyer Frank Orr. But few are aware that he spent his early years in Oxnard, where he ruffled enough feathers to create a name for himself. His rebel spirit served him well, not only in the courtroom, but also behind the typewriter. Gardner was born on July 17, 1889, in Malden, Massachusetts. His parents moved west in 1899 and, in 1902, settled in Oroville, California, where his father could do some gold dredging. Erle earned several school suspensions and took up amateur boxing. He found employment as a clerk in a legal office in Willows, California. He enrolled at Valparaiso University in Indiana but dropped out after a boxing match with his professor led to a warrant for his arrest. He spent time traveling in California and reading law in various law offices. In 1911, at the age of 21, he passed the bar. His first office was in the quiet town of Merced, California, but he found the pace too slow and the summer weather too hot. When a boxing buddy suggested he would find more excitement in Oxnard, Gardner did not hesitate. He joined the Law Office of I.W. Stewart and met a young secretary from Mississippi named Natalie Frances, whom he married in April 1912. Upon moving to Oxnard, Gardner earned an immediate reputation by defending members of the Chinese community who were being prosecuted by the district attorney for gambling. While illegal gambling was certainly taking place in Oxnard, Gardner found a way to get his clients off the hook. Before one client was picked up for trial, Gardner instructed him to trade places with an individual named Wong Duck. After the sheriff realized he had brought in the wrong person, the headline in the paper announced, "Wong Duck May be the Wrong Duck," placing Gardner and his client in a favorable position. Gardner was also involved in a case in which he and law partner D.A. Stuart proved that the Pacific Mail Order House had duped Henry Maulhardt out of $5,000 when they claimed to be able to provide the needs of its customers from the "cradle to the grave." After proving that the company had only $300 on its shelves despite claims that it had millions, closing arguments concluded, "The evidence shows no ten million dollar melons but lemons by the bushel." (Author's collection.)

Erle Stanley Gardner's
VENTURA
Birthplace of
PERRY MASON
by RICHARD L. SENATE

Illustrated by
John Anthony Miller
Cover Design by
James C. Cannon

Erle Stanley Gardner, Beyond Oxnard

In 1916, Gardner joined the law firm of Orr & Gardner. He moved to San Francisco shortly thereafter and, for the next three years, worked as a representative for Consolidated Sales, selling automotive products to manufacturing plants. In later years, he cited this experience as the foundation for his sales career as a writer. Gardner rejoined the Orr firm in 1921 and began writing fiction around the same time. He wrote constantly and submitted numerous stories despite early rejection letters. By the end of 1921, his story "Nellie's Naughty Nighty" was published in the pulp magazine *Breezy Stories*. Another early story was called "The Police and the House." After inadvertently reading a brutal and uncensored criticism of one of his stories, Gardner rewrote the "The Shrieking Skeleton" that *Mask Magazine* paid $160 to publish in 1923. Gardner's goal was to produce 100,000 words each month. He practiced law by day and often wrote two or more stories at night. He used several pseudonyms, including Charles Green, Kyle Corning, and Grant Holiday, among others. By the early 1930s, Gardner had two book-length manuscripts that were both rejected by *Collier's* and the *Saturday Evening Post*. Eventually, his work was discovered by the William Morrow Publishing Company. The fictional character Perry Mason was developed at this time, and in 1933 the first *Mason* book, *The Case of the Velvet Claws,* was written in Ventura in the Gardner Building at 21 South California Street. In 1934, Gardner bought property in Temecula, California, and by 1940, he left law practice for good. He also left a legacy in one of his early hometowns, Oxnard. (Author's collection.)

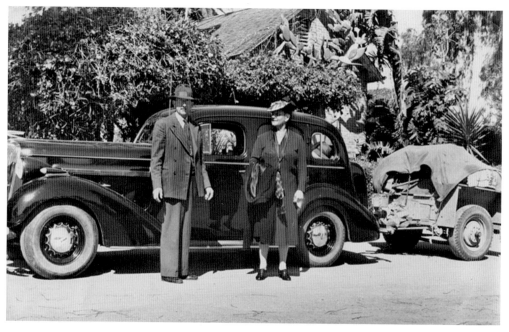

Lydia Fricker Pfeiler

Lydia Fricker Pfeiler belonged to the Ventura County Garden Club, the Oxnard Music Club, the Oxnard Community Players, and the art club. In 1904, she married Albert Pfeiler. Soon after, she purchased a Solomon's lily from Shepard's Nursery in Ventura. Every 25 years, the rare type of calla lily produced one bloom that lasted 10 days. A quarter century later, Lydia shared her blooming Solomon at Dr. Park's jewelry store. As part of the garden club, she planted the many hibiscus plants along the railroad tracks and local highway. Through her involvement with the Oxnard Community Players, she helped put on multiple plays at the Oxnard Opera House. Pictured above are Albert and Lydia Pfeiler getting ready for a trip to Oregon. Below is an advertisement from the *Oxnard Courier* for a play that Lydia directed. (Above, courtesy Bob Pfeiler; below, author's collection.)

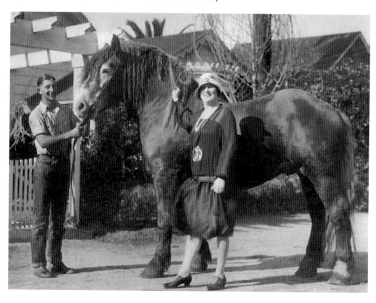

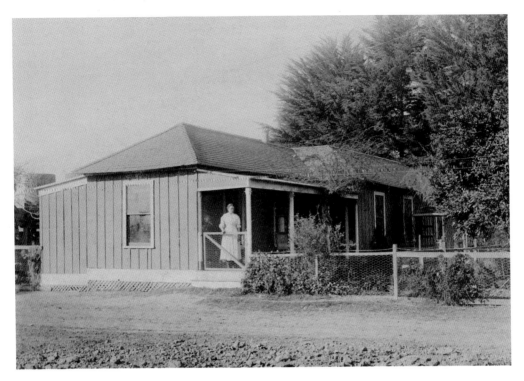

Effie Cooper Pell

Effie Cooper Pell was a regular at council meetings, hospital visits, and church services. The daughter of William and Hattie Simmons Cooper, she was born on the Cooper Ranch (now the Oxnard Multi Service Center) near Cooper Road in 1893. Her sister Estelle Cooper was the first graduate from Oxnard High School. In 1916, Effie and her husband, Malcolm Pell, were the first couple to be married at St. Paul's Methodist Church. She became the president of the Women's Society and led the sing fest every Sunday. Effie also taught Sunday school for 25 years. On May 10, 1980, St. Paul's honored her with the observance of an Effie Pell Day. Each May, Effie would sell poppies for charity. Hers is a legacy of selfless giving. She is pictured above at the Cooper Ranch and below on her wedding day. (Both photographs, courtesy Carrie Pell Dominguez.)

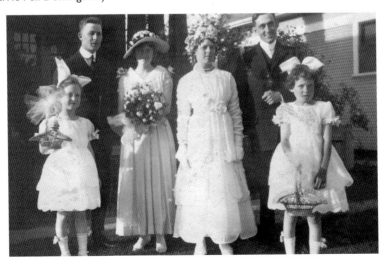

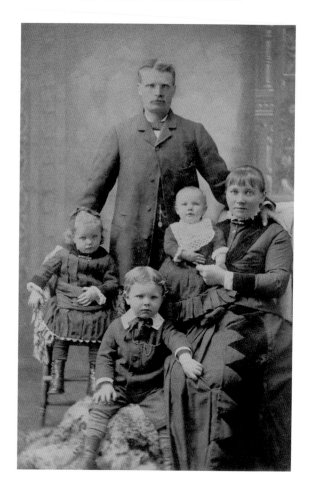

Gus Maulhardt

Gus Maulhardt, born on December 7, 1887, was a unique character with a life full of humorous anecdotes. He was the son of Heinrich Maulhardt and Augusta Wucherpfennig, who arrived in California in 1883 under the sponsorship of cousins Gottfried and Anton Maulhardt. The Heinrich Maulhardts were referred to as the "Rice Road Maulhardts" to distinguish them from their cousins on Rose Avenue. Gus, a footloose bachelor, was set up by Achille Levy with the town's new telephone operator, Evelyn Salkheld. They met at the popular Oyster Loaf Café in Oxnard and, soon after, they were married. For 48 years, Gus kept a journal in which he summed up each day with a one-line highlight. Samples include "rained about an inch," "paid Joe Vacca $12.00 for pigs," and "thrash beans." Despite the brevity of his journal entries, many amusing stories about Gus have been passed down. During Prohibition, for instance, Gus operated a still as a side job, and the sheriff himself was once involved in an accident after picking up his "gallon of booze" before an Elks barbecue. Another time, Gus hastily purchased a washing machine from a door-to-door salesman because he feared that the extended sales pitch would disrupt the water flow to the still. In another family tale, Gus and a friend were stationed up in the Newberry Park area as part of a hoof-and-mouth quarantine. When a young newlywed couple passed through on their way to their honeymoon in Santa Barbara, Gus an his friend had them get out of their car to be decontaminated with sheep dip (a fungicide used to protect sheep from parasites) before they were allowed to proceed. Gus lived in Oxnard at a time when life was simple, but he knew plenty of ways to liven things up. Pictured above is the Heinrich and Augusta Maulhardt family. On the right-hand page in the above photograph are Evelyn and Gus Maulhardt, and below is an excerpt from Gus Maulhardt's journal. (Above, author's collection; opposite page, courtesy Joe Maulhardt.)

June 2. Little Joseph Hugo was born.
— 3. Start cultivate beets 5th time cultivate beans
4. Start cultivate beans.
5. Mex hoe beets 3rd time + 2nd time home
10. cultivate corn 1st time
11. Sold little bull calf $6.50
17. Joe took track links to Thomas.
18. Evelyn + Joe came home from hospital
24. finish cultivate beans 2nd time
27. Start hoeing beans.
29. Mrs Wilmore came to work in afternoon
30. Got wood + boards from Gabbert ranch
30 Saloons out.

Catherine Antolino Mervyn

Known as "Mrs. Mervyn" to hundreds of students who were fortunate enough to be in her class, Catherine Antolino Mervyn was a master teacher before there was such a title. She taught in Ohio and New Mexico before she and her husband, Bill, settled in California. There, she taught at Parkview Elementary School, and her lessons incorporated every discipline. When studying California history, students created missions, performed a play, published a newspaper (the *Wagon Wheel Press*), and took a culminating field trip to the San Buenaventura mission. After retiring, the energetic Catherine only picked up the pace in promoting community spirit and spiritual awareness. She has written several books. Her first, *A Tower in the Valley: The History of Santa Clara Church*, was published in 1989, followed in 1998 by *Historic Moments with California Federation of Women's Clubs*. In 2002, Catherine researched and wrote *The Replication of the Father Serra Statue: A Volunteer Community Project*. She has also written several children's books, including *Sammy, Pepe and Mumbo-Jumbo*; *A Lesson from a Tree*; *Call Me Nona*; and *Obie and the Open Door and Monkey in a Cage*. She is pictured here in front of Santa Clara Chapel with the author. (Author's collection.)

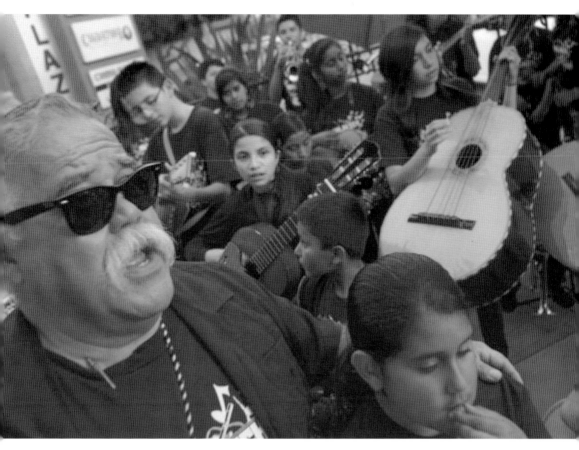

Javier Gomez

Javier Gomez can be described as an author, poet, dance instructor, historian, educator, actor (of both stage and film), playwright, producer, philanthropist, grant recipient, and loving parent and husband. Back in 1992, in reference to the many organizations he has either founded or been part of, the *Los Angeles Times* called him a "one man culture club." Javier began his 33-year career as a teacher in the Oxnard School District in 1973. He has worked tirelessly to bring about a better understanding of the Latino culture, and has created several organizations to further this cause. In 1976, he helped establish the Inlakech Cultural Arts Center, a bilingual program that promotes cultural awareness by offering a traditional Mexican Ballet Folklorico dance program, vocal and instrumental musical training, and a theater program. Other organizations that Javier has been involved with include the Ballet Folklorico Regional; the Café Inlakech, which he cofounded; and the Gomez Foundation Gomez, which he founded with his wife, Irene, to help secure funds to continue offering free-of-charge services to both youth and adults. (Author's collection.)

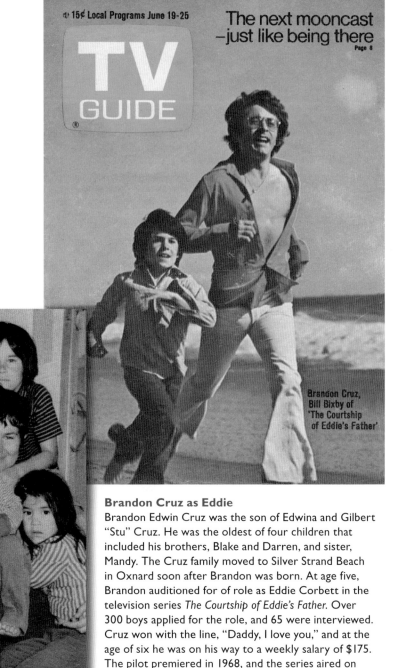

♪ 15¢ Local Programs June 19-25

TV GUIDE ®

The next mooncast
–just like being there
Page 8

Brandon Cruz,
Bill Bixby of
'The Courtship
of Eddie's Father'

Brandon Cruz as Eddie

Brandon Edwin Cruz was the son of Edwina and Gilbert "Stu" Cruz. He was the oldest of four children that included his brothers, Blake and Darren, and sister, Mandy. The Cruz family moved to Silver Strand Beach in Oxnard soon after Brandon was born. At age five, Brandon auditioned for of role as Eddie Corbett in the television series *The Courtship of Eddie's Father*. Over 300 boys applied for the role, and 65 were interviewed. Cruz won with the line, "Daddy, I love you," and at the age of six he was on his way to a weekly salary of $175. The pilot premiered in 1968, and the series aired on ABC until it ended in 1972. Cruz and costar Bill Bixby grew to be lifelong friends, and as Cruz told *American Profile* magazine, "Bill Bixby was like my second father." (Author's collection.)

Beyond Eddie

Cruz continued his acting career for several years, making guest appearances in television shows like *Kung Fu*, *Gunsmoke*, and *The Incredible Hulk* (which starred his former costar Bill Bixby). Cruz also appeared in *The Bad News Bears* as Yankee pitcher Joey Turner. In the 1980s, Brandon began playing in the punk band Dr. Know. He also served as lead vocalist with the Dead Kennedys from 2001 until 2003. His brother Darren is also a musician, leading various incarnations of the popular ska/reggae-flavored band the Ska DaddyZ. In the 1990s, Brandon was active in A Minor Consideration, a support group for child actors and former child actors that was founded by Paul Petersen. As of October 2011, Cruz was working as a case manager at Walking Miracles Malibu, a drug and alcohol recovery program in Southern California. He later admitted, "Surfing and punk rock probably saved my life." He married actress Liz Finkelstein in 1994, and they are the parents of a son and daughter. Their son's middle name, Bixby, is in honor of Cruz's costar and second father. (Author's collection.)

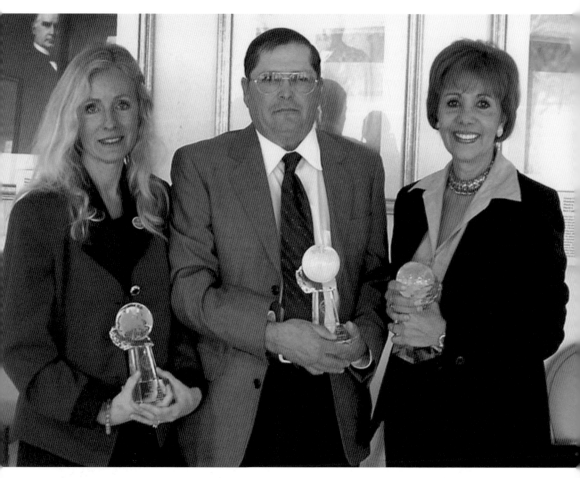

Morey Navarro

Modesto "Morey" Navarro attended Santa Clara High School, where he met the biggest influence in his life, coach Lou Cvijanovich. Years later, while raising money for the sports programs, Morey approached the coach and confessed that many of the donors assumed he was an All-Star athlete. The coach responded, "Shut up and let them think what they want as long as they keep giving to the program." Morey has been an ambassador for the city of Oxnard and has earned several awards, including the Bahá'í Human Rights Awards in 2005. He was chosen because of his "selflessness, generosity and eagerness to serve others. He also spearheaded a campaign to rename a portion of Laurel Street in front of Santa Clara High School in honor of his lifelong coach. The name change was approved after several years of work, and on May 12, 2012, a ceremony was held to honor Lou Cvijanovich as a fire truck delivered the new sign designating Coach C Lane. Morey has been an advocate for the Oxnard Historic Farm Park Museum, putting together his many contacts to restore the site. Pictured from left to right at the 2005 Bahá'í Human Rights Awards at the Ronald Reagan Library in Simi Valley are Teresa Langness, Morey Navarro, and Ferial Masry. (Courtesy Modesto Navarro.)

John Flynn

John Flynn has given his constituency 32 years of public service and plenty of projects to be proud of. After several years a teacher, John decided to run for county supervisor. He ran on a quality-of-life platform and knocked on the door of every voting household in the Fifth District, which at that time included the city of Oxnard and all of the city of Port Hueneme. Later, Oxnard College hired Flynn as a division director for the Business and Public Services Division, and during his three years at the school, John helped develop the Hotel and Restaurant Management Program. John Flynn is known for getting things done, and for this reason many people in Ventura County call his office directly, ignoring district lines. In addition to influencing many positive changes in the community, he has influenced his son Tim, who has followed in his footsteps as a teacher and politician, serving on the council for the City of Oxnard and winning the 2012 mayoral election. (Courtesy Diane Flynn.)

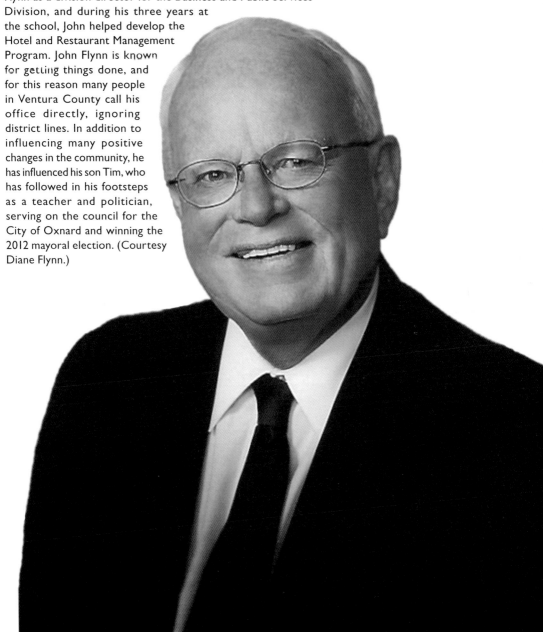

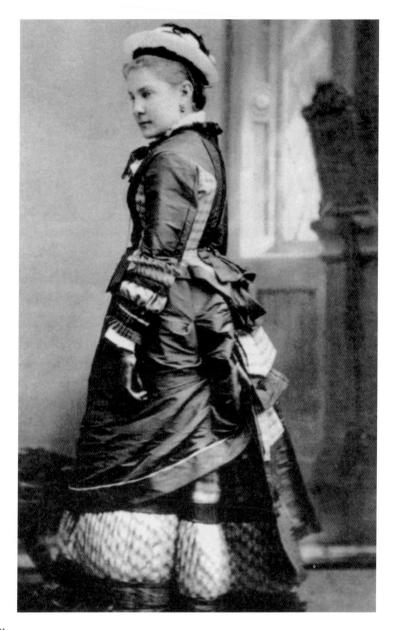

Lucy Levy

Lucy Levy, from Paris, France, met her husband, Achille Levy, through a marriage broker. They married in 1882, and Lucy was in for the shock of her life when she arrived at her new home, which featured dirt roads and lacked indoor plumbing. She became involved in the newly established Ventura County Fair, taking charge of the cooking entries in 1891 and, by 1895, becoming chairwoman for the department of flowers and plants. She also served on the board of the Ventura County Red Cross, established a library, planted trees along the main streets, and added sidewalks. Lucy had a generous and caring spirit, which she demonstrated by extending personal loans to help young farmers, like Mike Vujovich, get their start. Furthermore, her son Joe readily admitted that he relied heavily on his mother's influence to keep the Bank of A. Levy growing. Lucy Levy not only helped her son and her husband gain success in their endeavors, she also hundreds of those less fortunate. (Author's collection.)

Connie Stallone Korenstein
While teaching third grade in Oxnard, Connie Stallone Korenstein began a quest to learn the town's history. She became a docent at Heritage Square in Oxnard. She researched the pioneer families and wrote the curriculum materials for her third grade students. Her work was published and officially adopted by the Oxnard School District in 2001, with the help of Jeff Maulhardt, the author of this history. Once retired, Connie devoted more time to living history presentations. She is an avid collector of Victorian costumes and has enjoyed creating a fashion show around the life events of her favorite historical figure, Annette Petit Laurent. Parisian socialite Lucy Levy, who came to California in the 1880s, is another favorite. Connie has also written living history presentations on women's suffrage and on Sarah Josepha Hale, the woman who is responsible for Thanksgiving's status as a national holiday. (Courtesy Connie Korenstein.)

Lucy Hicks

While the nation was caught by surprise when *Time* magazine announced in November 1945 that Lucy Hicks was a man who for 30 years had masqueraded as a woman, many Oxnard residents were not so taken aback. As Paul Laubacher stated years later, "She was the only woman I saw that had a 5 o'clock shadow." Her tall stature, big shoulders, and large hands and feet were also tip-offs. She often looked after the children of the farming families and frequently participated in baseball games with them. Her ability to throw the ball harder than the young boys she looked after was also a clue, according to John McGrath. Yet, despite these signs, most people attributed the unusual behavior to "Lucy just being Lucy." Lucy was born Tobias Lawson in Waddy, Kentucky, in

1886. It was reported that, as a child, she insisted on wearing a dress and began calling herself Lucy. Her mother took her to a doctor and was advised to raise Lucy as a girl. Lucy left home at 15 and found employment in Pecos, Texas. By 1920, she married for the first time to Clarence Hicks and lived in New Mexico. It is not certain whether or not Clarence was as surprised as the doctor who examined Lucy in 1945 would be, but he deserted Lucy in Oxnard in 1926, and she filed for divorce in 1929. She worked for many of the local farming families, and a 1930s census listed her as a servant with the Charles Donlon family. Paul Dynes Donlon remembered Lucy hanging her many colored wigs on the clothesline. She owned her own Model T and a home at 662 South B Street.

She was arrested several times for bootlegging, and (as she was known for taking over the kitchen) each such incident meant the promise of a fresh pie for the jailers. When not behind bars or filling in at one of the ranches, Lucy ran a catering business with Althea Weston at the Elite Café, located at 219 West Seventh Street, which specialized in fried chicken and group home cooking with free delivery. After the repeal of Prohibition in 1934, Lucy turned to another black market: prostitution. She ran a brothel for several years, with much success during the war years of the 1940s. However, 1945 saw an end to both her business and her time in Oxnard. When one of her ladies passed on a social disease to a patron from the Navy, Lucy and her girls were ordered to take a physical. Dr. Hilary R. Mangan made the discovery. While the disease was difficult to trace, Lucy's gender was not. Lucy protested, stating, "I have lived, dressed, acted just what I am, a woman." She was charged with perjury, not because she fooled the community, but because she had deceived the government by signing a marriage license stating she was a women and the wife of serviceman Ruben Anderson in 1944. Lucy was collecting allotment checks from the government. After her conviction, she spent one year in jail and was given 10 years probation. She spent her final years in Los Angeles, passing away in 1954. (Courtesy of Bert Donlon.)

CHAPTER FIVE

Sports

Sports have always played an important role in the recreation of the residents of Oxnard. Baseball was Oxnard's first love, from the formation of the first team in 1900 to the day Fred Snodgrass brought the Giants to Oxnard. Oxnard has been home to factory teams and All-Star high school squads, and Oxnard College has seen many of its players promoted to the next level, either by scholarship or by draft pick to the majors. Many, from Ken McMullen to Terry Pendleton, have graduated from the base paths of Oxnard to the big leagues. Boxing, with participants including Sam McVey and the Garcia family, is another popular sport in Oxnard, and enthusiasm for the sport of football has grown increased as Dallas Cowboys have chosen Oxnard as their favorite summer practice facility. Coaching in Oxnard has always been strong, and the bar was set high by the winningest high school coach in California history, the legendary Lou Cvijanovich.

The Olympics

Clarence "Bud" Houser, the most notable Olympic athlete to hail from Oxnard, graduated from Oxnard High School in 1922 (the school's football stadium was later named Houser Field in his honor) and then enrolled at UCLA. He was born in Winigan, Missouri, on September 25, 1901. As a high school student, Houser participated in the California State Track Meets between 1920 and 1922. His six wins in shot put and discus (each breaking a state record) made him the most successful meet participant ever. During this time, he developed a discus-throwing style of turning rapidly one and a half times in the circle before releasing—a method that has been copied by many later athletes. At the 1924 Summer Olympics in Paris, Houser won the gold medal in both the shot put and discus, and he remains the last Olympian to have done so. He won national championships in the discus in 1925, 1926, and 1928, and in the shot put in 1921 (while still in high school) and 1925. On April 3, 1926, in Palo Alto, at a dual meet with the University of Southern California (USC) and Stanford, he set a world record with a discus throw of 48.20 meters. At the 1928 Summer Olympics in Amsterdam,

he was flag bearer for the US team. He also retained his title in discus throwing. Now a practicing dentist in Hollywood, Houser is a member of the National Track & Field Hall of Fame, an inaugural member of the Ventura County Athletic Hall of Fame, and a member of the Oxnard High School Hall of Fame. Other Oxnardian Olympians include Peter Dwight Donlon, the son of Charles and Laura Donlon who joined Houser at the 1928 Olympics and won a gold medal as part of the United States' rowing team, and David Laut, another shot-putter who graduated from Santa Clara, where he played for legendary coach Lou Cvijanovich. Laut went on to win the bronze medal at the 1984 Summer Olympics in Los Angeles. He also won the gold medal at the 1979 Pan American Games and the bronze at the 1981 IAAF World Cup. His personal best throw was 22.02 meters, which he achieved in August 1982 in Koblenz. In 1997, he was named to the Ventura County Sports Hall of Fame. Finally, Fernando Vargas is two-time world champion boxer who won a bronze medal as an amateur at the 1995 Pan American Games in Mar del Plata. This 1928 sports card of Clarence "Bud" Houser shows him after he tossed the discus for an Olympic record of 135 feet and 2 inches during the Amsterdam games. (Author's collection.)

98

Marion Jones
Marion Jones is a former world champion track-and-field athlete and a former professional basketball player. She attended Rio Mesa High School for her freshman and sophomore years, then transferred to Thousand Oaks for her final two years. Jones won the California Interscholastic Federation State Track and Field Championships in the 100-meter sprint four years in a row. She won five medals at the 2000 Summer Olympics in Sydney, Australia. However, she had to forfeit all medals after admitting in 2007 that she took performance-enhancing drugs. The International Olympic Committee stripped Jones of all five Olympic medals and banned her from attending the 2008 Olympics. After spending six months in jail, Jones has embraced a more important message than that of winning at all cost. She has spoken of the importance of "stepping back and talking to someone you trust" about important decisions and emphasizes the importance of surrounding oneself with the right people. She has earned her way back to respectability with her dedication to helping young people. (Author's collection.)

Baseball

Oxnard's first sport was also America's pastime. From the inaugural years featuring local teams to Oxnard's first professional baseball players like Fred Snodgrass and Charley Hall, baseball was the attraction for Sunday afternoons. Snodgrass spent nine seasons playing professionally with the New York Giants and the Boston Braves. He was also instrumental in bringing the Giants to Oxnard in 1913 for an exhibition game against the Chicago White Sox as part of their World Tour. Many Hall of Famers played in the game—Sam Crawford hit a homerun, John McGraw filled out the line up card, Bill Klem called the balls and strikes, and Christy Mathewson pitched the Giants to a victory, despite three hits by Tris Speaker. At that time, with the major leagues still decades away from including the West Coast, teams like the Oxnard Merchants and the Oxnard Aces were sponsored by organizations and businesses. Many major leaguers, including George Stovall, New York Giants catcher John "Chief" Meyers, and knuckleballer Tom Seaton, would play winder ball at the Oxnard Athletic Field off E Street and Wooley Road. The Aces featured many young men who worked at the sugar factory. Among the players listed in the 1946 *Oxnard Courier* are Louie Castro, Manuel Escalante, Bob Ornales, Joe Uranga, Virgil Wiltfong, and Chuck Yokam. The Oxnard High baseball teams of the 1950s also produced dozens of talented baseball players who went on to become quality softball players, local coaches, and professional players. Denver "Denny" Lemaster, for instance, signed with the Milwaukee Braves in 1958 to a hefty bonus of $60,000 and made his debut in 1962. He played 11 years in the majors with the Braves, the Astros, and the Expos, and even made the 1967 All Star team. Lemaster's teammate Ken McMullen signed with the Dodgers in 1960 and made his debut two years later. He spent 16 years in the majors, playing for the Dodgers, the Senators, the Angels, the Dodgers, Oakland, and the Brewers. He slugged 156 homeruns and had eight seasons of double-digit homers. Terry Pendleton is the local player who has had an MVP year in the big leagues. Pendleton graduated from Channel Islands High School and played at Oxnard College and Fresno State before being drafted by the St. Louis Cardinals in 1982. In 1991, while playing with the Atlanta Braves, Terry batted .319 with 22 homeruns with a .517 slugging percentage and knocked in 86 runs to earn the Most Valuable Player award for the National League. He played 15 seasons in the big leagues and hooked on with the Braves coaching staff in 2002. (Author's collection.)

Oxnard College Baseball

The Oxnard College baseball program has served as a factory line to the major leagues since its 1978 inception in 1978 by Jerry White. White graduated from Oxnard High and went on to teach and coach at Hueneme High. He was joined by his former teammate Charles "Buster" Staniland. Buster played 10 years in the minors, mostly with the Cardinals organization. He hit 26 homeruns in three different seasons and 148 in his professional career. Several of Jerry White's former players have taken over his program, including Jon Larson and Roger Frash. The program has sent 11 players to the major leagues, while nearly three dozen have been drafted to the big leagues. Among those who have reached the ranks of the majors are Jerry Willard (1979), Terry Pendleton (1980), Kevin Gross (1981), Mark Berry (1982), Howard Hilton, (1983), Doug Simmons (1985), Tim Laker (1988), Josh Towers (1996), Jack Wilson (1998), and Paul McAnulty (2001).

The drafted players who passed through the Oxnard College mill include Kevin Coughlon (Cardinals), Curt Thrasher (Royals), Roger Frash (Mets), Johnson Wood (Brewers), Rob Duran (Brewers), Scott Ninneman (Cardinals), Ernie Carrasco (Cardinals), Scott Kershaw (Yankees), Richard Sauer (Brewers), Dan Flores (Tigers), Robert Chadwick (Cubs), Pat Waid (Royals), Oliver Nichols (Brewers), Scott Baker (A's), Charles Harrington (Astros), Adam Springston (Braves), Brok Butcher (Angels), Curtis Leavitt (Twins), Justin Frash (A's), Eric Komatsu (Yankees). In a little over 30 years of baseball, nearly 100 players have earned scholarships beyond Oxnard College. There have been hundreds of players from the Oxnard area that were drafted by the big leagues; to list them would take several chapters and another book. However, it is worth mentioning those who were drafted in the first round, a rare feat to which the Oxnard area is uncommonly accustomed. Randy Elliott, who played at Camarillo High, was drafted by the Giants in the first round. Mike Parrott, another Camarillo Scorpion, went to the Orioles in 1973. Roderick Patterson played for Don Cardinal at Channel Islands and then pitched at Santa Monica College, where he was drafted by the Reds in 1976. Out of Hueneme High and Oxnard College, Roger Frash was chosen in 1980 by the Mets. Kevin Gross became the first pick out of Oxnard College when he was drafted by the Phillies in 1981. The Giants chose Jacob Cruz out of Channel Islands in 1994. Dmitri Young played at Rio Mesa High and was drafted by the Cardinals in 1991. His brother, Delmon Young, played at Camarillo and was drafted as the first overall pick in 2003 by Tampa Bay. Other Oxnardians who made it to the majors include Aaron Small, Steve Trachsel, and Bobby Ayala. (Courtesy Alan Maulhardt.)

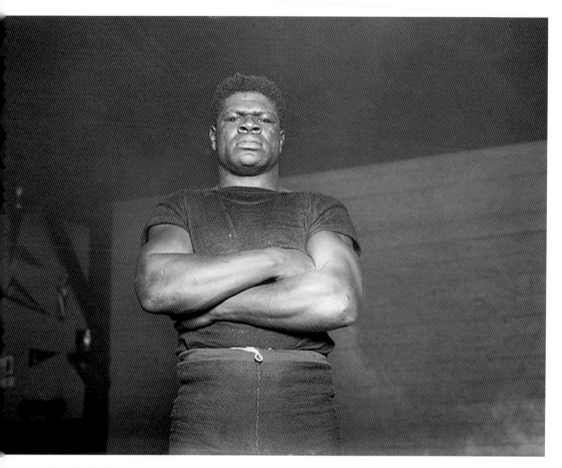

Boxing is Born
From the days of China Alley and the 17 saloons in town, Oxnard has always been known for its fights, and professional boxing has been particularly popular. The first ring, the Oxnard Athletic Club, was constructed on A Street in 1901 next to the Louis Brenneis shop. The first fight was between Frank Fields, who had previously worked for the Donlon brothers, and Jack McCloskey. Fields won and went on to win 29 more decisions in his favor. The first area fighter of notoriety was Sam McVey. McVey was born in Texas, but his career began in Oxnard, where he was working as a stable boy for W.A. Roche. He made his professional debut in 1902 and went on to win 63 times. Jack Johnson called him the toughest fighter he ever faced. Once Johnson won the crown, he refused to fight McVey for fear of losing the title. The boxing venues in Oxnard changed with the growing interest. Soon, the Athletic Club was too small. The Masonic Auditorium was used for bigger crowds, and the Oxnard Opera House, located a few doors down on C Street, hosted the majority of the local fights. From the 1920s to the 1950s, Simon Cohn offered the El Rio Legion Stadium. Boxing lessons were offered for amateurs and professionals, ages of eight and up. After World War II, wrestling also gained popularity. (Courtesy Ed "Kettlebell" Maulhardt.)

A Boxing Legacy Continues

A resurgence of interest in boxing came about with the careers of Roberto Garcia and Fernando Vargas. Vargas was trained by Eduardo Garcia at La Colonia Youth Boxing Club and went on to record 26 wins against only 5 losses. He won his first world title in 1998, knocking out Yori Boy Campas seven rounds for the International Boxing Federation's light-middleweight championship. He successfully defended the title throughout 1999, relinquishing it in 2000 to Felix Trinidad. Meanwhile, the Garcia family also figures very prominently in Oxnard's boxing legacy. In addition to Eduardo Garcia's accomplishments as prolific trainer, his sons Roberto and Miguel "Mikey" Garcia have also found success between the ropes. Roberto won 32 professional fights, earning the title of IBF Super Featherweight Champion. He has followed in his father's footsteps and became a trainer, operating the Robert Garcia Boxing Academy. He now trains youths, young adults, and professionals. Included among his successful clients are Nonito Donaire Brandon Rios, and his own brother Mikey Garcia. Since his first KO in 2006, Mikey has already racked up 29 victories against no losses. He has earned featherweight-champion status in the United States Boxing Association, the World Boxing Organization, and the North American Boxing Organization. Others who have trained in Oxnard include Carlos Martinez, Adam "Bomb" Flores, Victor Ortiz, Daniel Cervantes, Brian Viloria, and Mia St. John, and it is certain that many more will continue to travel to this mecca of boxing training. (Author's collection.)

Lou Cvijanovich, the Early Years

Lou Cvijanovich, the future "winningest high school coach in California history," was born in 1926 om the mining town of Jerome, Arizona, to Yugoslavian parents. His father, Luka, came to Arizona to work at the copper mine of Cleopatra Hill, 150 miles north of Phoenix. After a mining accident cost him his sight in one eye, though, he worked in a bar that he eventually took ownership of. (Years later, his grandsons Sam and Steve Cvijanovich would follow suit, opening their own bar, Sam's Saloon, in Oxnard.) Upon graduation from Jerome High School, Lou joined the Navy. He next enrolled at Arizona State College and was recruited to come to Oxnard in 1952. Lou taught at Wilson Junior High where, in his first year, he coached the B team. The B team was recruited to play against the bigger A teams in Oxnard for the annual Rotary Club Basketball Tournament. Lou's undersized squad outhustled the A team to win the championship, and a coaching legacy began. (Courtesy Martha Cvijanovich.)

Lou Cvijanovich, High School Coaching Legend
In 1957, Lou became Camarillo's first varsity baseball coach, the junior varsity football coach, and the C basketball coach. After one year, he got an offer from the Santa Clara Boosters, which included Jack Burdullis and Floyd Miller. During his first year at Santa Clara, his team won a CIF championship, and under his leadership, the school was on its way to 15 CIF Championships, including three California State Championships (1989, 1990, and 1999) and an unprecedented 30 league championships. Lou used several mottos to motivate his players, telling them that, "Mental and physical toughness comes within one's pride," that "pressure and pride equal success," and instructing them to use "work ethic and desire to become a better person." He was also a master at fundraising. The school was $50,000 short for the completion of its $1-million gymnasium, so Friedrich Pavilion, Lou, and booster Ed Knight had a brainstorm. They organized a dinner event for boosters in the old gym, and, as Cvijanovich recalls, "We got 304 people. I put up the number 50 on the scoreboard, 15 minutes on the scoreboard clock and announced that I wanted that 50 erased by the time the clock expired." By the time the clock had run down, $63,000 had been raised. Cvijanovich has been inducted into the California High School Sports Hall of Fame (1999), the California Coaches Association Hall of Fame (1998), the National High School Hall of Fame (1997), and the Ventura County Athletic Hall of Fame (1989). In 1996, Santa Clara High School renamed its Cvijanovich Gymnasium in his honor. He posted 104 wins in football, earning a pair of CIF championships and seven league crowns. In his time as the baseball coach, Cvijanovich guided the Saints to a 114-30-2 record, one CIF title, and five league championships. He is the only coach in the history of California's preparatory schools to win CIF championships in football, basketball, and baseball. In May 2012, "Coach C" was honored once again, this time with the renaming of the street in front of the school he served for over four decades. He is pictured here at an induction ceremony for Santa Clara High on October 27, 2012. (Author's collection.)

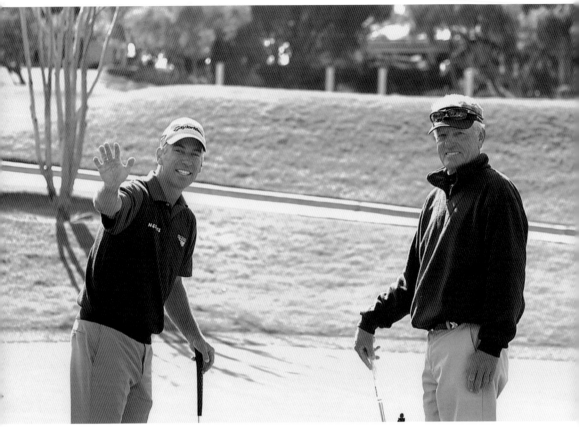

Corey Pavin, Oxnard Beginnings
Oxnard's most famous golfer, Corey Allen Pavin, was born on November 16, 1959. He spent his early years playing with his brothers at Las Posas Country Club, and his golf coach, Bruce Hamilton, helped him get his game to competition level. The results started to show in the summer of 1977 after Pavin graduated from Oxnard High School with wins at the Junior World and Los Angeles City Championships. He was recruited to play golf for UCLA, where his teammates included future PGA Tour players Steve Pate, Jay Delsing, Tom Pernice Jr., and Duffy Waldorf. In 1982, he won the PAC-10 title and was named College Player of the Year. He won two gold medals at the 1981 Maccabiah Games and turned professional the following year. In 1983, he posted three international victories. Pavin mastered the ability to curve the ball left or right from the tee. In 1984, his first full year as a PGA Tour member, he averaged 258.8 yards per drive to rank in the middle of the pack. His first PGA Tour victory was in 1984 at the Houston Coca-Cola Open. (Courtesy Lisa Pavin.)

Cory Pavin, Accomplishments
Pavin spent over 150 weeks in the top 10 (his highest ranking was fifth) of the Official World Golf Rankings between 1986 and 1997 and topped the PGA Tour's money list in 1991. He won the US Open in 1995 and won his 15th career title in 2006 at the US Bank Championship in Milwaukee. On July 27, 2006, Corey broke the record for the fewest number of strokes needed to complete nine holes at a PGA Tour event, with an 8-under-par score of 26. His 36-hole total of 125 tied the record for fewest shots taken in the first 36 holes of a PGA Tour event, matching the efforts of Tom Lehman, Mark Calcavecchia, and Tiger Woods. He has played on three Ryder Cup teams—1991, 1993, and 1995—compiling an 8-5-0 record, and was named captain of the 2010 Ryder Cup US team. In October 2010, the US Ryder Cup team lost 13.5 to 14.5 against the European team. In 2010, Pavin began playing on the Champions Tour, and in February 2012, he won his first Champions Tour event at the Allianz Championship. (Courtesy Mike Ehrmann.)

Football

While the sport of football is a lot younger than the American pastime of baseball, its influence on the athletes in Oxnard has been on par in recent years. On November 9, 1995, Hueneme High School senior Ronny Jenkins got everyone's attention when he set a national record. Jenkins carried the ball 30 times and gained 619 yards with 7 touchdowns, crushing the previous record by over 100 yards. He entered the professional ranks in 2000 with the San Diego Chargers and went on to set a franchise record with 67 returns for 1,531 yards followed by

26.6-yard return average for 1,541 yards. After three seasons with the Chargers, Jenkins signed with the Raiders; he then spent two years with the Calgary Stampeders in the Canadian Football League. Wide receiver Charles Dillon, another Hueneme graduate, played for Ventura College and Washington State University before signing with the Indianapolis Colts. Injuries cut his season short, but, undeterred, Dillon signed on with the Spokane Shock of the Arena Football League, helping them win the Arena Cup X in 2009. He earned an invitation to camp with the Green Bay Packers, then returned to the Shock squad. In 2011, Dillon signed on with the Chicago Rush. Kevin Thomas played for the Rio Mesa Spartans the at the University of Las Vegas before being drafted as a cornerback by the Buffalo Bills in the sixth round in the 2002 NFL draft. Lorenzo Booker played his high school ball at St. Buenaventura and eventually found his way to the backfield of the Chicago Bears, Philadelphia Eagles, and Minnesota Vikings. After a successful high school career as a tight end in football and a center in basketball, six-foot-five-inch Jacob Rogers followed up his graduation from Oxnard High School with an All-American effort as an offensive tackle at USC. He was drafted in the second round by the Dallas Cowboys, and later played a stint with the Denver Broncos. Rogers's USC teammate, Hueneme High graduate (and all-time reception leader for the Trojans) Keary Colbert played wide receiver for several NFL teams, including the Carolina Panthers, Denver Broncos, Kansas City Chiefs, and Seattle Seahawks. Offensive lineman Blaine Saipaia graduated from Channel Islands High School then Colorado State. Though he was not drafted, Saipaia earned a spot on the St. Louis Rams squad for the 2004 season. He also spent a season with the New Orleans Saints. Scott Fugita graduated from Rio Mesa High and then walked on at California State University at Berkeley before being drafted by the Kansas City Chiefs. Stints with the Cowboys, Saints, and Browns followed. Scott was part of the heartwarming New Orleans Saints victory at Super Bowl XLIV in 2010 in the wake of the devastation of Hurricane Katrina. The locals of Oxnard will never forget seeing the smiling faces of Scott Fugita's family as Scott hoisted his daughter on his shoulder pads during the postgame celebration on the field. (Courtesy Dean Maulhardt.)

CHAPTER SIX

Entertainment
Music, Actors, and Writers

The final curtain call for this legendary series covers musicians, actors, and writers—the entertainers of Oxnard. The city offered the Opera House and the Pagoda Bandstand. The Opera House burned down in 1922, and bands were banned from the Pagoda due to fire hazard restrictions. Music in the park continued, but most of the plays and performances took place at the schools. By the late 1960s, music began to move out of the school auditoriums and gymnasiums to ballrooms and skating rinks. The Mixtures and the Dartells committed their music to vinyl. Novelty songs about Oxnard began to find their way to jukeboxes. Record stores began to cater to the youth. Music business entrepreneur Jim Salzer got his start in Carriage Square. Two decades later, Tony Cortez began his reign as the figurative mayor of Nardcore. Rudolph Valentino filmed *The Sheik* on the sands of Hollywood Beach, and Sonny and Cher found a beach home they could cruise to on the weekend. Darryl Brock used his Oxnard childhood to frame one of his many baseball novels, and Michelle Serros has made every Oxnardian proud of her writing accomplishments.

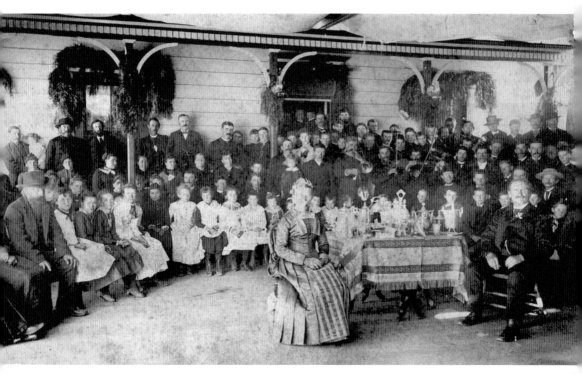

Early Music

Music has always been a part of the scenery of Oxnard. Many prominent and influential musicians have claimed the alluvial soil as their home. The first musicians in the area were from the Gonzalez family. Felipe Gonzalez, son of original grantee Rafael, played the violin and guitar and was listed in the census record as a musician. He taught the children of many of the farming families, including the eldest of the Ed Borchard family, Will Borchard, who became part of the Gonzalez/Borchard orchestra. The Pagoda (opposite page) was built in 1910 to cover the water pump in the middle of the park. The next year, a middle floor was added to create a bandstand. The first performance was by the Frank Botts–led Oxnard Military Band on Saturday, July 29, 1911. The band was funded through subscriptions and an initial contribution of $15 from the city. By January 1914, the St. Joseph's Institute band, led by J.H. Hall, became the replacement band. However, after a few years, the fire department limited the use of the bandstand to solo performers and speeches. Evangeline Carroll Laubacher was a regular vocalist. By the 1920s, the Salvation Army band played regularly at the foot of the pagoda. In the 1940s, Tony Avila's Orquestra Mutualista jazz band performed frequently as well. In the 1950s, Arthur Henson conducted the Parks and Recreation band. Another musical and entertainment venue was the Oxnard Opera House. Built in 1906 as the Dreamland Skating Rink, the building was empty most of the time until it was converted into an opera house and opened to the public in April 1909. Vaudeville was popular in the day, and the Opera House also showed movies and held boxing matches. However, by 1922, the wooden building had fallen behind the times. It eventually burned. In the c. 1887 photograph above, Gonzalez family musicians are playing for some of the earliest farming families, including members of the Borchard, Donlon, Friedrich, Kauffman, and Hartman families, at the home of Gottfried and Sophie Maulhardt for their silver wedding anniversary. (Above, author's collection; opposite page, courtesy Gary Blum.)

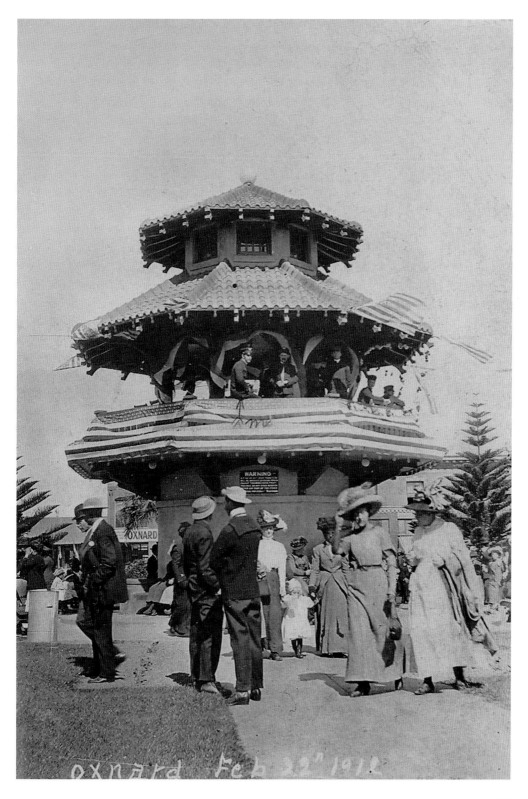

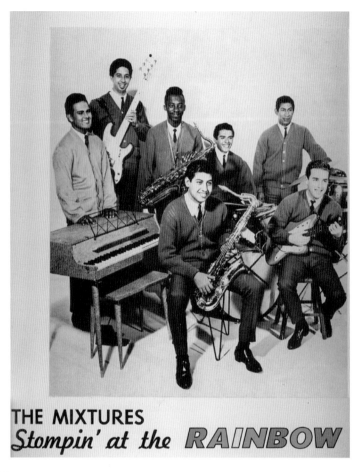

THE MIXTURES
Stompin' at the RAINBOW

The Mixtures

The Mixtures were a local band from the early 1960s that started playing while at Oxnard High School. With Steve Mendoza on piano and Delbert Franklin on saxophone, they formed a group called the Playboys. They were joined by Leroy "Zag" Soto on bass, Danny Pollock on guitar, Autry Johnson on horns, Eddie Robles on drums, and Johnny Wells on percussion. The band members were from a variety of ethnic backgrounds—African American, Mexican, Caucasian, Native American, and Puerto Rican. But, as Delbert Franklin pointed out later, "It might sound strange now but it's true. At school, at jobs and in music, if there was racist stuff going on it was people talking amongst themselves, no one told us that we couldn't [play together]." The blend of backgrounds and musical styles inspired the band to change its name to the Mixtures. With the addition of local sax player Jess Porras, they played school auditoriums, roller rinks, and private parties, and eventually caught the attention of local KACY-AM DJ Dick Moreland, who introduced them to Los Angeles music promoter Eddie Davis. The band began playing nightclubs like the Rainbow Gardens in Pomona, Legion Stadium in El Monte, and the amusement park in Santa Monica, Pacific Ocean Park. They became the house band for *Parade of Hits*, a weekly live music series that aired on Los Angeles television station KCOP. On the show, they backed up such artists as Roy Orbison, Frankie Avalon, Bobby Rydell, and Paul Anka. Things were looking up for the band. They recorded a "live" album, *Stompin' at the Rainbow*, in 1962 on Linda records and featured some of the Mixtures original tunes and some great covers, along with an introduction by disc jockey Bob Eubanks. Most of the cuts were studio recordings with a live sound added at the time of mixing, but the rest of the tracks were recorded live by recording engineer Wally Heider. The group broke up in the mid-1960s. (Author's collection.)

The Dartells

By the early 1960s, there were many groups playing around town, including Howard Deere & the Videls, the Customs, the Mixtures, the Vibrators, and Fred Kushon. These bands played at local venues like Trade Winds, the Carousel, Dapper Dan's, the Wagon Wheel Restaurant, and the Roller Gardens. However, few made it to vinyl, and even fewer made the pop charts. The Casuals formed while in high school in 1959. They became house band at the Roller Gardens in Wagon Wheel. Other bands that played the rink were the Four Seasons, the Beach Boys, and the Righteous Brothers. The Casuals performed a song called "The Casual Stomp" (eventually known as "The Dartell Stomp"). Guitarist Dick Burns later recalled, "When we'd play it, everyone would just kind of stand there and raise one foot, then the other." By 1962, the group—consisting of Doug Phillips (vocals and bass), Dick Burns (guitar), Gary Peeler (drums), Randy Ray (organ), Rich Piel (saxophone), Corky Wilkie (saxophone), and Galen Mills (guitar)—won the attention of manager and record producer Tom Ayers, who sent them to Los Angeles to do some background recording for Wink Martindale. As part of their payment, they were allowed to record a one-take track. The result was the hit song "Hot Pastrami," recorded under the name The Dartells. The song was a takeoff of Nat Kendrick & the Swans' 1960 song "Mashed Potatoes." The original release came as a surprise to the group, who were not aware the song would be released. Then Dot Records picked the song up for national distribution, and it peaked at No. 11 on the US pop chart in 1963. During the single's success, the group appeared on *The Munsters*, and an album was released soon after. The second single, "Dance Everybody Dance," peaked at No. 99. The album also included a song called "I Scream" and an instrumental homage to the Oxnard coastline called "Surf Dreams." The group split up shortly thereafter. Lead singer Doug Phillips later played in New Concepts, Cottonwood, and the group Rain. Burns went to Vietnam and, upon returning, played with several different groups, never putting down his guitar despite having to take a day job. While their musical career was short-lived, the band's contribution to the dance music of the early 1960s lives on. (Author's collection.)

113

Jim Salzer, the Oxnard Connection

There are many cities, including Ventura, that can claim some part in the accomplishments of Jim Salzer. However, it was in Oxnard that Salzer opened his first record store and began his tenure as a promoter for legendary rock acts such as the Doors, Jimi Hendrix, and the Rolling Stones. Jim Salzer himself was a pop singer, born in 1942 into a tough factory neighborhood in Chicago. He graduated high school in 1960, and his family moved to Milwaukee. His mother played piano, and his father, guitar. Jim became a guitarist and singer and would sit in with bands such as the Dynamics, who played Chuck Berry tunes and cutting their own records that sold well on the local scene. In 1962, Salzer moved to California and lived in a shabby beach house in Venice. He performed with Dick Dale and His Del-Tones. Salzer went to work for an interior decorating firm, first in Orange County and then in Ventura, where he began taking in the music scene. He went to local gigs and, in a few months' time, was managing 10 groups. In 1966, he took over the old Arcade Records store in south Oxnard. He opened a second location in north Oxnard, sold his condo in Ventura, and moved into a back room of one of his stores. He was not the only one to sleep over; legendary guitarist Jeff Beck spent two weeks there as well. He closed the south Oxnard store but kept the north Oxnard store open, changing its name to Salzer's Music Emporium. (Courtesy Jim Salzer.)

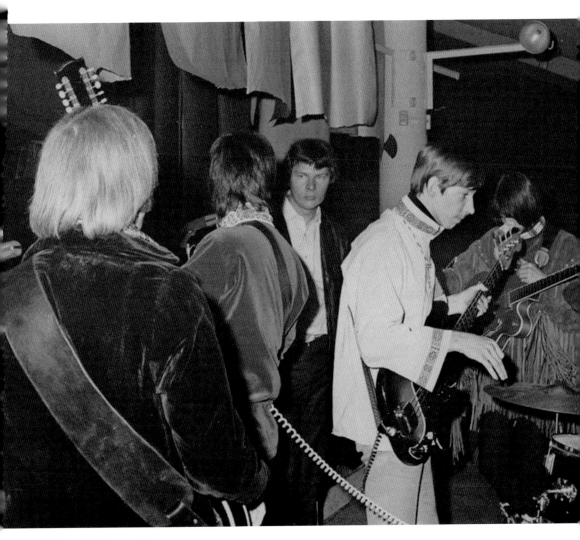

Salzer the Promoter

Around the same time, Salzer's success booking local rock talent led to him bringing in big-name groups for concerts in large venues, such as the Earl Warren Showgrounds in Santa Barbara and the old Starlight Ballroom in Oxnard. Between 1966 and 1971, Salzer booked and promoted an estimated 350 rock-and-roll shows, including the Rolling Stones, Jimi Hendrix, and Led Zeppelin. He also briefly managed the Doors, whose lead singer, Jim Morrison, could be difficult. Salzer recalled "walking aimlessly" with Morrison for three hours one night through the streets of San Francisco's Haight-Ashbury district. Hendrix, on the other hand, "was a total gentleman" in business dealings. Neil Diamond once rehearsed at Salzer's garage in Ventura. Salzer booked the Stones to do two shows in one day in 1967, using a Lear jet to transport them between the venues in San Bernardino and Bakersfield. The first performance, however, was marred by a riot. "By the time we got to Bakersfield," Salzer recalled, "they had heard about that and wanted to cancel the show. So I had to do some fast talkin' that day." His last show was a Zeppelin/Jethro Tull bill in 1971. After that, feeling that the business was becoming too cutthroat, he stopped promoting and opened Salzer's Mercantile at its Victoria-Valentine location in 1972. He has kept an Oxnard connection over the years, and lived in the Andrew Borchard house in Carriage Square from 1980 to 1993. He is pictured here on stage with Buffalo Springfield. (Courtesy of Jim Salzer.)

Nardcore

Nardcore is a hardcore punk movement that originated in Silver Strand Beach, Oxnard, and Port Hueneme during the early 1980s. The big four were Agression, Dr. Know, Ill Repute, and Stalag 13, with other bands including False Concessions, Habeas Corpus, RKL, and Scared Straight. The first venues to regularly host punk shows in the Oxnard area were Casa Tropical; the Oxnard Armory; the Town and Country and Skate Palace, both in Port Hueneme; the Mayfair Theater and Bandar, both in Ventura; and Casa de la Raza in Santa Barbara. Much of the early promotion of Nardcore came from Mystic Records in Hollywood, founded by Doug Moody and Mark Wilkins. Tony Cortez is considered the "mayor" of Nardcore. He played guitar as an original member of Ill Repute—along with John Phaneuf (vocals), Jimmy Callahan (bass), and Carl Valdez (drums)—and currently fronts the Loads, who continue with the same intensity. The nardcore symbol (spelled out in block letters and including a skeletal head wearing a black cap in the "O" of the name) was scribbled in a notebook by Ismael Hernandez of Dr. Know. Pictured is Tony Diaz from the band Ill Repute. (Courtesy Bill Parry.)

Beyond Nardcore

The Nardcore family has spread out over the years and taken on new directions. One prominent member of False Confessions, Scotty Morris, went on to form Big Bad Voodoo Daddy with Kurt Sodergren. In addition to recording with major record labels Capital Records and Interscope, the band played the halftime show for Super Bowl XXXIII in 1999. Another False Confessions member, Harry Meisenheimer, went on to play for both Stalag 13 and III Repute before becoming the drummer for the Cramps (under the name "Harry Drumdini"). Vocalist (and former child star) Brandon Cruz, originally lead singer for Dr. Know, formed a follow-up band called MDCN+MN (pronounced *Medicine Man*). Spinning off from the Nardcore scene is the music of Jeff Hershey, who had become a prominent fixture of the Ventura County music scene when he was just in his teens. He was a founding member of the local heavy metal band Black Opal before joining the band No Motiv, which released several albums on Vagrant Records and toured nationally. By 2005, Hershey started a new project in a different musical direction. Hitting the stage as Jeff Hershey and the Heartbeats, Hershey's performances channeled the essence of his punk background into a classic sound in the vein of Sam Cooke and Otis Redding. The band's debut record, *Soul Music Vol. 1*, was released in May 2011 on Siren Records. It was recorded at the Pow Wow Fun Room in Los Angeles, California, live to analog tape (in keeping with the technology of mid-20th-century recording) and was engineered and mixed by Pete Curry of Los Straightjackets. In May 2012, the band played the South By Southwest music festival and, that fall, they embarked on a European tour of 17 shows in 17 days. More broadly, the Oxnard music scene had major influence on all punk rock music. The band NOFX, for instance, was influenced by III Repute. Eddy Burgos, aka Numbskull Productions, was in a band called Habeas Corpus. The Nardcore torch has been carried on by many groups, including In Control; Missing 23rd; Retaliate; and the Todd Jones groups Carry On, Terror, and Blacklisted. Pictured is Jeff Hershey. (Courtesy VC Buzz.)

Jaime and Gilbert Hernandez

Jaime and Gilbert Hernandez grew up in a household of comic books, and by their teen years, their interests had expanded to punk rock. Their other brother, Ismael, formed the seminal Nardcore band Ill Repute. To quote Gilbert, "Punk made me cocky enough to believe that I could do a comic book . . . I took that musical anarchy to comics." Jaime's central characters are Maggie Chascarillo, a gifted apprentice "pro-solar mechanic," and Hopey Glass, an antiauthoritarian "punkette." These were the kind of women that populated the first issue of *Love & Rockets*. The magazine was initiated by older brother Mario and bankrolled by younger brother Ismael. A copy was sent to Gary Groth, the editor and publisher of the *Comics Journal*, who offered to publish their work under the new comics imprint, Fantagraphics. The Hernandez brothers produced 50 issues of *Love and Rockets*. They turned to producing solo books, with Jaime doing several featuring his Locas characters, but they eventually resumed their collaboration on *Love and Rockets*. (Author's collection.)

Otis Jackson Jr., "Madlib"
Otis Jackson Jr. is a DJ, multi-instrumentalist, rapper, and music producer. He goes by the name "Madlib," among multiple other pseudonyms. Otis, born in Oxnard in 1973, began producing hip-hop music with his friends in the early 1990s, eventually forming a group known as CDP. His first commercially released music was production for Tha Alkaholicks in 1993, followed by a release of his group's 12-inch EP "Ill Psyche Move" by Lootrack. They signed with Stones Throw Records in 1998. Under the name Quasimodo, Jackson released the album *The Unseen*, which was named by *Spin Magazine* as one of the top 20 albums of the year. In 2001, Otis began a series of releases from Yesterdays New Quintet, a jazz-based, hip-hop— and electronic-influenced group he created and for which played all the instruments. His growing number of pseudonyms came to be known as "Yesterday's Universe." He was invited to remix tracks from the Blue Note Records archive in 2003 and released *Shades of Blue*, which included a combination of remixes and newly recorded interpretations of Blue Note originals, many of which were credited to members of Yesterdays New Quintet. (Author's collection.)

Hollywood in Oxnard

Hollywood came to Oxnard in 1920. The blockbuster film *The Sheik* made Rudolph Valentino into the industry's biggest star, and the film location in Oxnard became a destination for tourists as well as homeowners. The sand dunes of the Oxnard shoreline doubled as an Arabian desert, complete with 200 artificial palm trees that were later transported to the Cocoanut Grove nightclub at the Ambassador Hotel in Los Angeles. By 1922, the film was the highest grossing film in Hollywood's early history. Interest in the location grew to the point that two couples decided to develop a beach colony to capitalize on the craze. Men's hats were left in the closet in favor of the slicked-back look of Rudolph Valentino. The Latino workers from the Oxnard sugar factory were called "chiques," a combination the English *sheik* and its Spanish counterpart, *jeque*. To capitalize of the tourists making the pilgrimage to the filming location, William and Frances Lingebrink and Bill and Alma Dunn came up with a plan to sell 500 lots for $200 each, charging $25 down followed by monthly payments of $10. The Hollywood Beach subdivision was approved on June 4, 1924, and a competing subdivision at Silver Strand Beach was recoded the following year on October 3, 1925, by another group of investors, Roland and Julia Casad. A third subdivision, Hollywood by the Sea, followed. Located between Silver Strand and Hollywood Beach, this project's developers included merchant storeowner Lean Lehmann, M.M. Kaufmann, E.G. Carter, B.O. Miller, and Margaret Harris. Papers were filed in August 1826, and lots were offered by the following year. (Courtesy Jean Marie Wilson.)